THE BRANCH LINES OF EAST ANGLIA

Harwich Branch

Andy T. Wallis

AMBERLEY

Dedicated to GRM and Timer Pete.

Front cover top: No. 31225 working a return overhead line foundations train back to Ipswich depot on 29 July 1983. (ATW Collection)

Front cover bottom: LNER Class V1 locomotive No. 7680 working an Up local passenger train from Harwich Town on 2 October 1948. (ATW Collection)

Back cover: A Class J15 locomotive working a local goods train between Bradfield and Mistley on 6 October 1951. (ATW Collection)

First published 2020

Amberley Publishing
The Hill, Stroud
Gloucestershire, GL5 4EP

www.amberley-books.com

British Library Cataloguing in Publication Data.
A catalogue record for this book is available from the British Library.

ISBN 978 1 4456 9526 6 (print)
ISBN 978 1 4456 9527 3 (ebook)

Typeset in 10.5pt on 13pt Sabon.
Typesetting by Aura Technology and Software Services, India.
Printed in the UK.

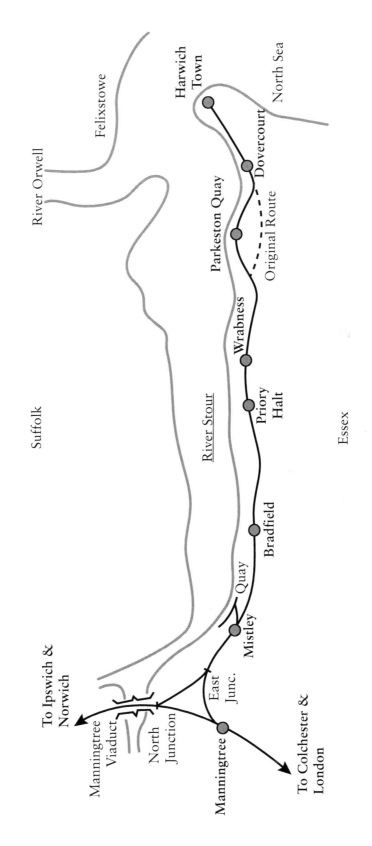

HARWICH BRANCH

Felixstowe

River Orwell

North Sea

Harwich
Town

Dovercourt

Parkeston Quay

Original Route

Suffolk

Wrabness

River Stour

Priory
Halt

Essex

Bradfield

Quay

Mistley

East
Junc.

To Ipswich &
Norwich

Manningtree
Viaduct

North
Junction

Manningtree

To Colchester &
London

Introduction

During the nineteenth century, at the height of railway building, most towns and villages had access to a railway, which helped considerably in the movement of goods and people who previously had to rely on horses, carts and the canals for the transportation of freight over long distances.

Essex, part of East Anglia, was predominantly an agricultural area with some heavy industry in the major towns and cities. By the 1860s, Essex had two main lines from London to Colchester, Ipswich, then on to Norwich. The other line ran from Liverpool Street through Broxbourne to Bishop's Stortford and eventually on to Cambridge, Norwich and King's Lynn. These lines were slowly augmented with a network of branch lines that linked most areas to the new railway; most of these lines were constructed in the later part of the nineteenth century.

This volume is intended to cover the branch line to Harwich, which is located in Essex. This railway is still very much open today and serves the port of Harwich International, formerly Harwich Parkeston Quay. The branch has been electrified and all the stations survive apart from Bradfield, which closed in 1956, and Priory Halt, which closed in the 1960s. Most of the smaller stations are unstaffed with passengers buying tickets from machines or from the conductor guards. The majority of passenger trains commence their journey at Manningtree, where good connections are made from main line services serving London, Colchester, Ipswich and Norwich. We start our journey at Manningtree and travel along the branch, calling at all stations to Harwich Town. Photographs of every station will feature, including historic views taken before the modernisation of the 1980s.

The encouragement of passenger traffic to and from the continent was started by the Great Eastern Railway and was further developed by the London & North Eastern Railway and British Railways. Today, all the boat trains are formed of hauled coaching stock or electric multiple units. A large Freightliner depot was built at Harwich Parkeston Quay and has had good and bad times, having to compete with the Port of Felixstowe on the other side of the River Stour.

This book is well illustrated with a good selection of photographs from both the steam and diesel era and should appeal to those interested in railway history and those interested in history generally.

A Short History of the Harwich Branch Line

The Harwich branch started life in 1847 when the Eastern Union Railway obtained powers to build a line from Manningtree to Harwich. Manningtree had been on the railway map since June 1846 when the EUR opened its line from Colchester to Ipswich. The Harwich branch was opened on 15 August 1854, construction having been delayed by railway politics between the EUR and Eastern Counties Railway.

Construction was estimated at £100,000 but eventually cost £177,000. Early losses once the line was opened nearly led to closure but the new Great Eastern Railway formed in 1862, and the first continental steamers operated from Harwich Pier in 1863. The GER invested heavily in its new services and what started as weekly sailings soon developed into daily services to such destinations as Rotterdam and Antwerp. Services continued to expand with a new port at the Hook of Holland opening in 1893. Esbjerg and Gothenburg were added to the places served from Parkeston Quay.

With the growth in continental traffic, in July 1874 the GER authorised the construction of a new station and pier at Parkeston Quay. It was built one and a half miles upstream from Harwich on reclaimed marshy land. It opened in 1883 with a wooden pier capable of berthing seven vessels. The London & North Eastern Railway rebuilt the piers in concrete during the 1920s.

The branch was originally opened as a single track in 1854 and had stations at Mistley, Bradfield, Wrabness, Dovercourt and Harwich. Development of the branch went hand in hand with the increase of both freight and passenger traffic; accordingly, in 1866, the branch was doubled from Manningtree to Mistley. Further work followed the construction of Parkeston Quay. In 1882 a 1¾-mile diversion was opened to serve the new extension and double tracking was completed throughout the branch, this including an Ipswich-facing spur at Manningtree.

Local passenger services were five a day and in 1874 were increased to thirteen a day, which included some through services to Ipswich and Colchester. Mistley Quay was provided with a short branch, large maltings were established and later in the twentieth century saw the making of fertiliser and animal feed, which further increased traffic considerably. The quay also handled imported timber. The only station to see little growth was Bradfield, which closed in 1956.

In 1923, the Harwich branch part of the GER became part of the LNER, which continued to invest in the branch opening of Parkeston Quay West in 1934. This lasted until 1972. The LNER passed into the hands of British Railways in 1948 and the branch became part of British Rail Eastern Region. Later, in 1986, the line became part of Network SouthEast. Privatisation followed in 1997, the branch being run by various companies. Train services are currently run by Abellio East Anglia.

New signalling was provided with the doubling of the line in 1882. New boxes were provided at Manningtree East Junction, Mistley, Bradfield, Wrabness, Parkeston Goods Junction, Parkeston West, Parkeston East, Dovercourt and Harwich. Some reductions took place under the LNER. With the closure of Manningtree East in June 1925, its function transferred to Manningtree South signal box. Bradfield closed in 1924 and was replaced with a ground frame. New signal boxes were provided at Priory and Primrose, both near Wrabness, in connection with new Admiralty sidings being opened. In 1934, new boxes were provided by the LNER at two of the Parkeston locations.

The LNER commenced operating a rail freight train ferry service from Harwich Town to Zeebruge in 1924. Rail access was provided, and much traffic was carried until the ferries were withdrawn in the 1990s; the rail facilities are now disused and overgrown. The line between Parkeston Quay and Harwich Town was singled in 1968 as an economy measure; the former Down line was retained as a through siding. Prior to electrification, the branch signalling was renewed in May 1936, now being controlled from Colchester Power signal box and a new panel at Parkeston.

Parkeston Quay (opened in 1883) was renamed Harwich Parkeston Quay in 1934, finally becoming Harwich International in May 1995. Local passenger trains serve the intermediate local stations, whilst boat train services serve the boats to the continent. Freight services to the local stations were withdrawn in the 1960s; the last to go was the service to Mistley Quay and goods yard in the mid-1980s. Container traffic commenced in 1968 and peaked in 1986 when it started to decline in favour of nearby Felixstowe. There is now very little freight traffic on the branch.

Manningtree

An engineers' train relaying the level crossing at the station, seen on 11 May 2008. The level crossing is closed to traffic but the underpass remains open for cars. A Class 66 diesel is in charge of the train. (ATW Collection)

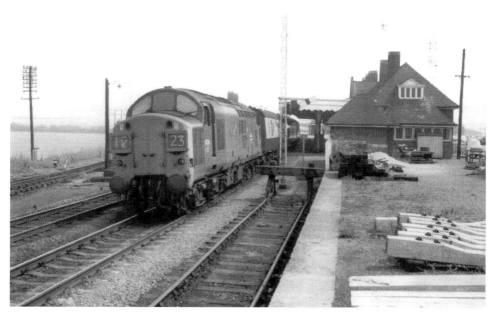

Diesel No. D6734 works the Up express 1K23 through the station. From around the 1960s, this image is post steam era but before this class of locomotive was reclassified to Class 37. (Dr. I. C. Allen/Transport Treasury)

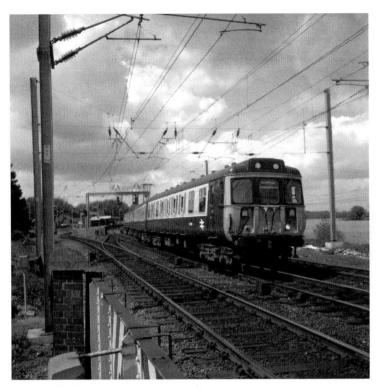

Class 312 EMU No. 312786 takes the Harwich branch at Manningtree South Junction on Saturday 24 May 1986. It was working the 10.10 through service from Liverpool Street to Harwich Town. (ATW Collection)

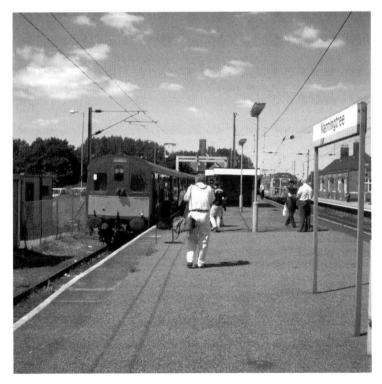

Preserved Class 307 EMU No. 307017 working the branch shuttle service on 14 June 1996. The Class 307s started life working between London and Shenfield in 1949. (ATW Collection)

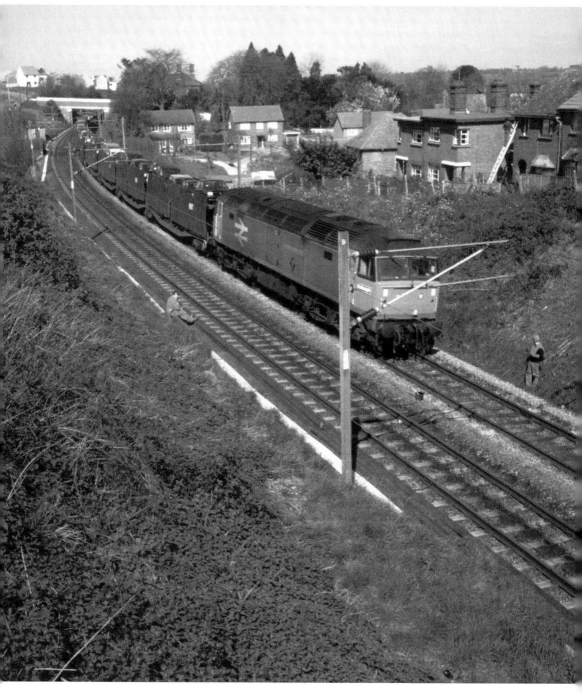

Splendid view of No. 47214, working a car transporter train near Manningtree on 28 April 1989. A couple of BR workmen in high visibility clothing look on. (ATW Collection)

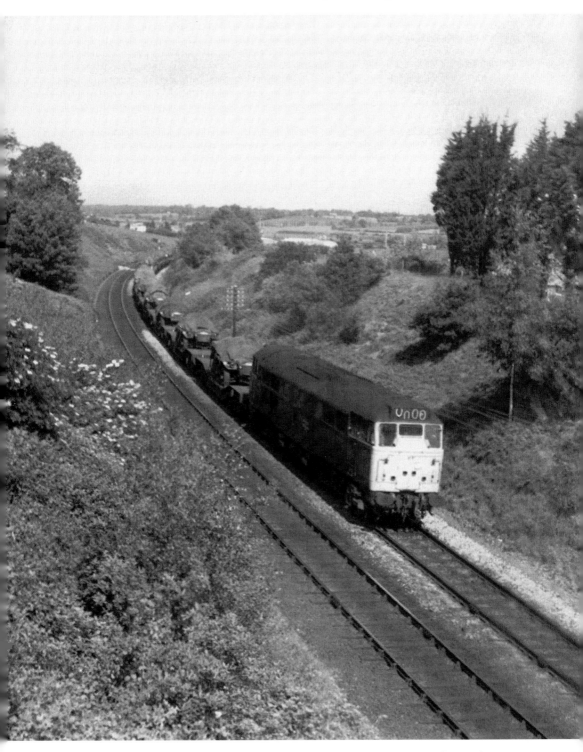

No. 31239 or 329 on an army vehicles train coming from the direction of Ipswich, seen near Manningtree East Junction on 9 June 1976. (ATW Collection)

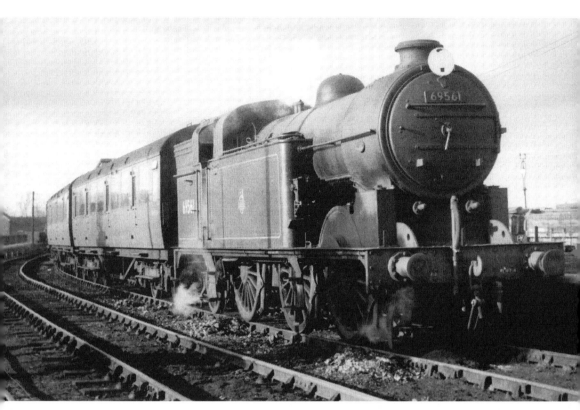

Class N2 locomotive No. 69561 is seen standing in the bay platform waiting to work the next shuttle to Harwich Town. In the early 1950s, BR sent three N2s to East Anglia for assessment of their suitability for working the branch shuttles. (ATW Collection)

An unidentified Class K3 locomotive working a Down boat train, seen here passing over the east junction on 8 July 1956. (ATW Collection)

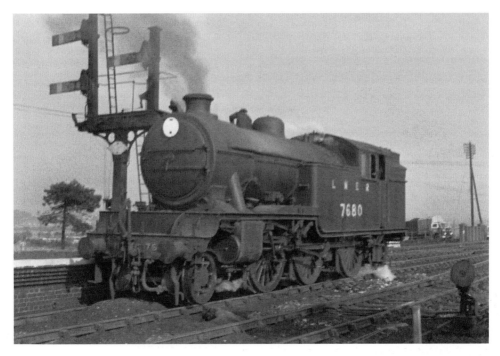

LNER Class V1 large 2-6-2 tank engine No. 7680 taking water at the end of the bay platform on 8 October 1948. Although well into the British Rail era the locomotive is still in LNER livery. (ATW Collection)

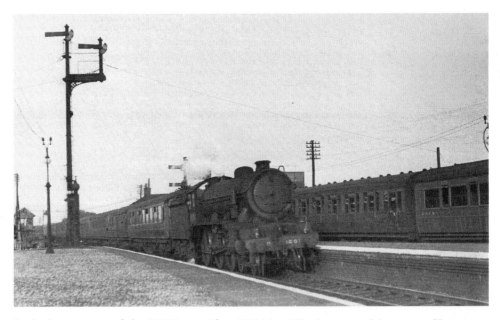

In the last summer of the LNER era, Class B17 No. 1601 is seen arriving on an Up express on 31 July 1947. Note the original GER lower quadrant platform starting signals, eventually replaced with BR upper quadrants on a steel structure. (ATW Collection)

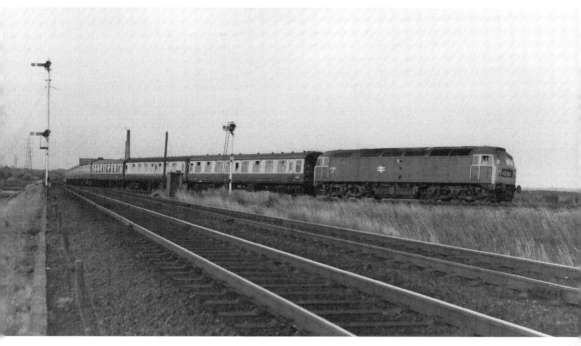

No. 47130, working a cross-country boat train, enters the north curve on Monday 14 July 1975. This train had started its journey at Manchester Piccadilly earlier in the day. (ATW Collection)

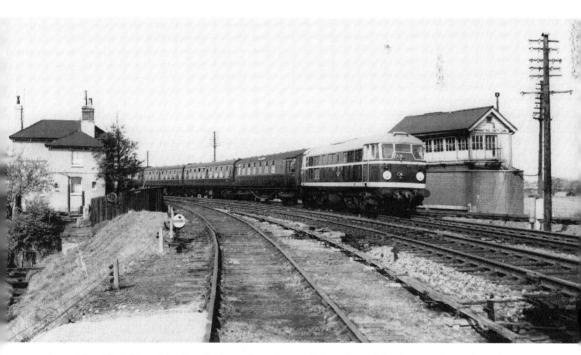

An unidentified Class 31 takes the branch at the south junction with a boat train working from London Liverpool Street on an unknown date. (ATW Collection)

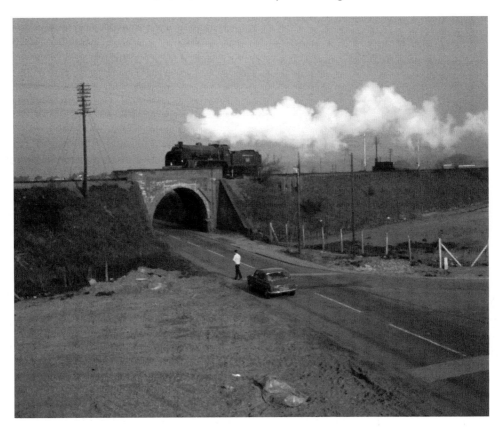

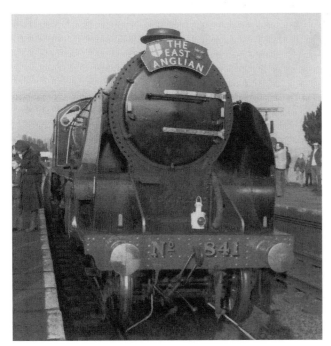

Above: Preserved Class S15 No. 841 *Greene King* is seen turning on the Manningtree triangle on 11 April 1976. The locomotive was based at the Stour Valley Railway Preservation Society site at Chappel & Wakes Colne station. This engine is now based on the North Yorkshire Moors railway. (ATW Collection)

Left: Front end view of Class S15 locomotive No. 841 whilst working a special train during April 1976. (ATW Collection)

A Class 100 Gloucester type DMU leading a three-car formation whilst working the 12.20 Manningtree to Harwich Town local service on Sunday 16 May 1976. It is seen near the east junction. (ATW Collection)

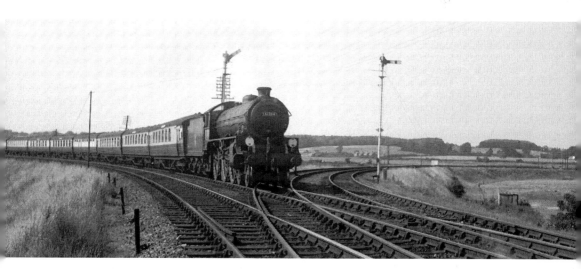

Class B1 locomotive No. 61264 working a Down boat train service, seen at the east junction on 8 July 1956. (ATW Collection)

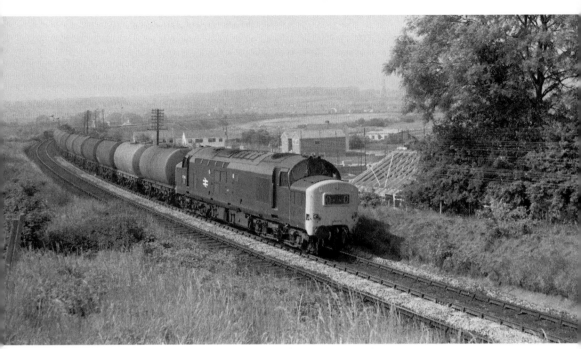

Class 37 No. 37326 passes the east junction with an oil tank train on 8 June 1976, several years before the electrification of the branch. (ATW Collection)

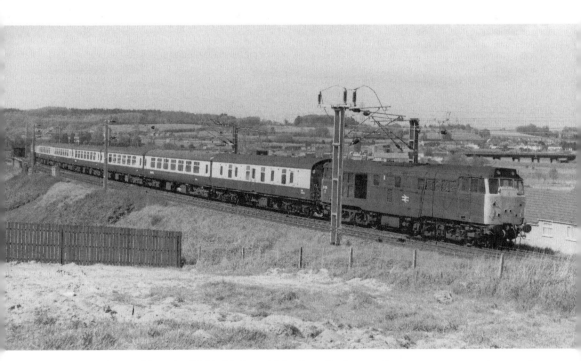

No. 31429 working the 07.20 Blackpool North to Parkeston Quay cross-country boat train service. It is seen as it passes the east junction on 16 May 1986. (ATW Collection)

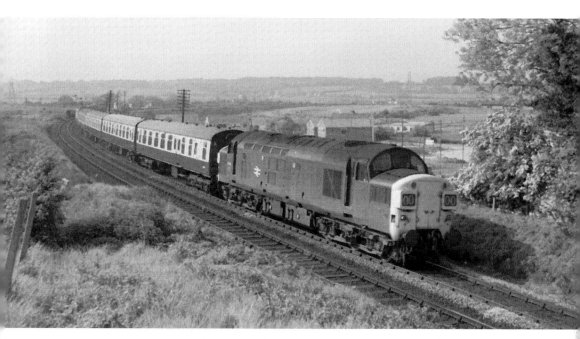

No. 37114 is seen passing the east junction whilst working the Down Scandinavian boat train from London Liverpool Street on 23 May 1976. (ATW Collection)

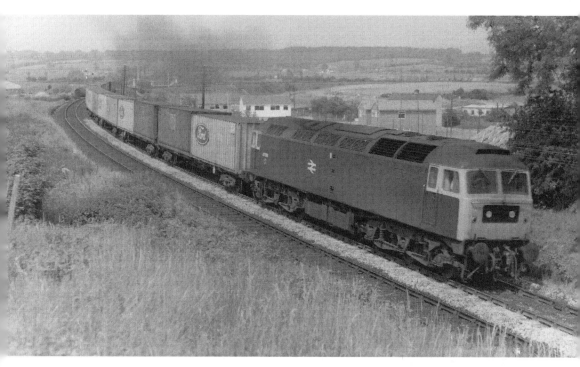

No. 47018 is seen passing the east junction at Manningtree whilst working the Ford motor car Freightliner service. It is en route to Harwich Parkeston Quay on 5 June 1976. (ATW Collection)

Mistley

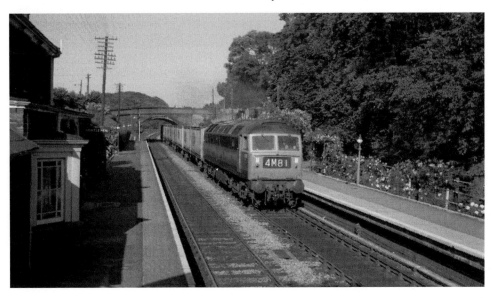

Class 47 No. D1889 working Ford Freightliner service 4M81 from Parkeston Quay to Halewood on 4 July 1969. (ATW Collection)

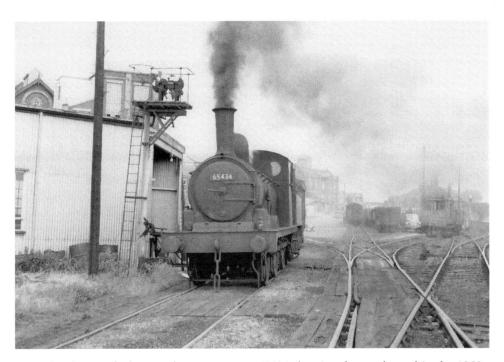

An undated view of Class J15 locomotive No. 65434 shunting the goods yard in the 1950s. Freight traffic arrived and was despatched from here until the mid-1980s. (Dr I. C. Allen/ Transport Treasury)

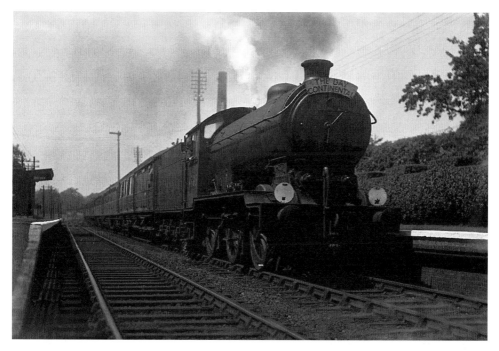

LNER Class J39 No. 4785 seen passing the station on 25 July 1948 with the 'Day Continental' boat train service. (ATW Collection)

A Class 101 Met Cam type DMU with small yellow warning panel arrives with an Up local service to Manningtree on 4 July 1969. (ATW Collection)

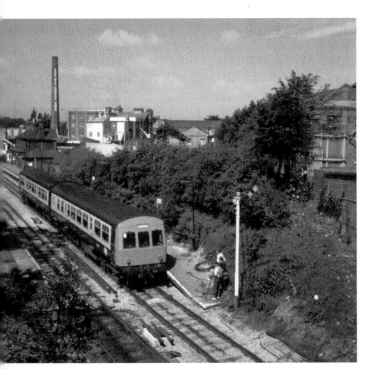

Above: A Class 37 locomotive leads an Up boat train working on Easter Monday, 19 April 1976, which was a warm and dry day. (ATW Collection)

Left: A Class 101 Met Cam DMU working the 10.49 Manningtree to Harwich Town local service, seen departing after its station stop on 27 June 1984. (ATW Collection)

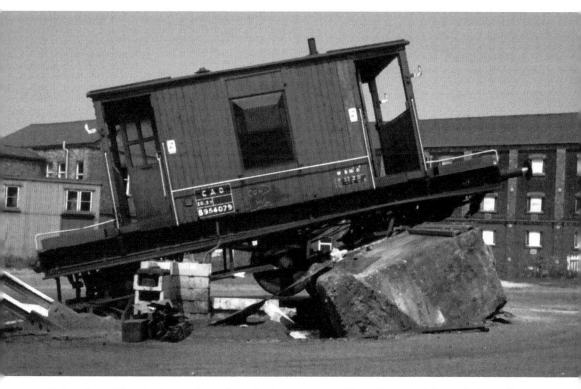

A shunting mishap in the goods yard as a brake van was accidentally pushed through the buffer stops onto a large boulder; the brake van has lost one set of wheels. This view was taken at 12.45 on 11 May 1982, a bright and sunny day. (ATW Collection)

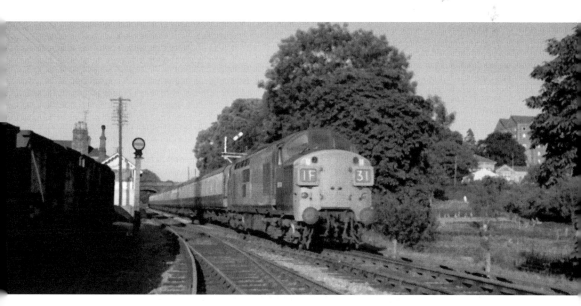

No. D6748 powers through the station whilst working train 1F31, the Up 'Day Continental' boat train, on 4 July 1969. (ATW Collection)

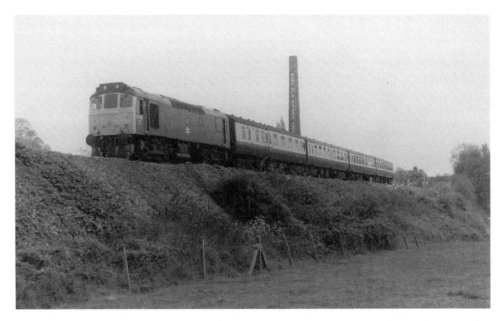

Diesel No. 25200 works a four-coach Harwich Parkeston Quay to Peterborough train away from the station on 19 May 1984. (ATW Collection)

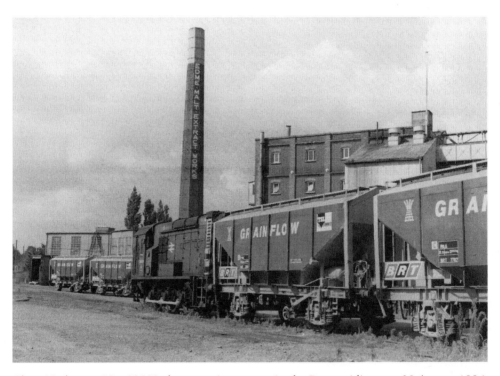

Class 08 shunter No. 08530 shunts grain wagons in the Down sidings on 29 August 1986. The tall chimney of the nearby malt works features a lot in views of the station. (ATW Collection)

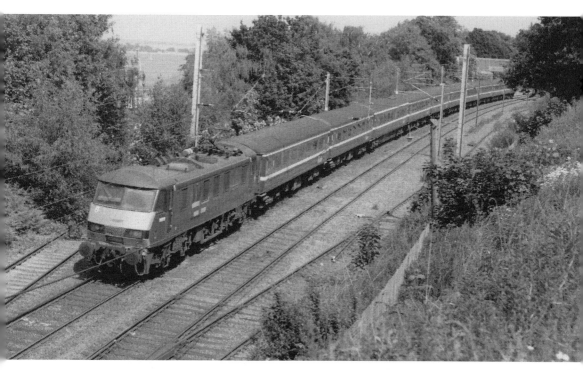

A Class 91 electric locomotive named *Penny Black* propels the Down boat train working on 24 May 2004. (ATW Collection)

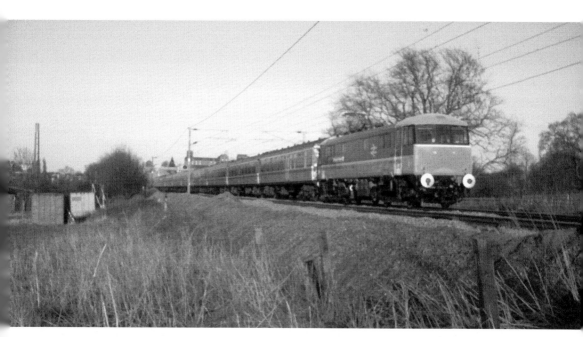

Having passed through the station, a Class 86 electric locomotive works an extra boat train to Liverpool Street from Parkeston Quay on Monday 21 April 1986. (ATW Collection)

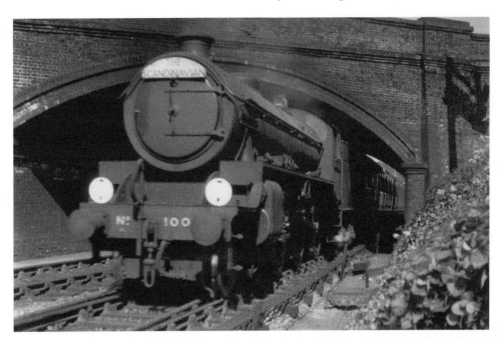

Class B1 locomotive No. 1006 works an Up to Liverpool Street with 'The Scandinavian' boat train service. It is photographed as it passes under the road bridge at the station on 16 May 1948. (ATW Collection)

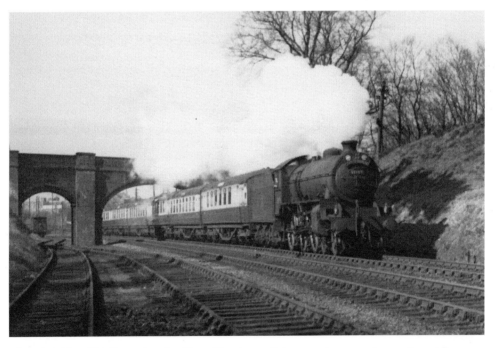

Class B1 No. 61149 works the 'Day Continental' boat train past the station sidings on 15 March 1952. (ATW Collection)

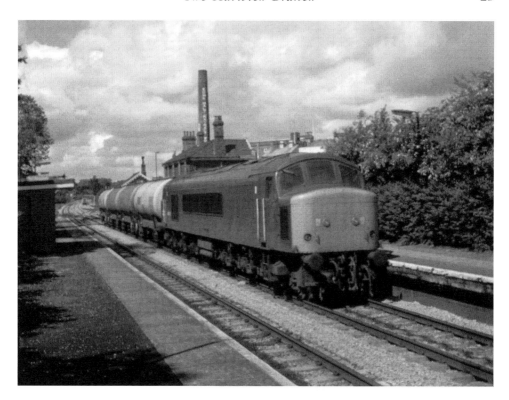

Above: Class 45 No. 45033 working the 19.23 Mossend to Harwich Parkeston Quay freight service, seen passing the Down platform with oil tanks on Saturday 2 June 1984. (ATW Collection)

Right: No. 47158 works a Freightliner trip from Ipswich to Harwich Parkeston Quay. It is seen on 24 July 1984 passing the station overbridge, which is in the process of being rebuilt for electrification clearances. (ATW Collection)

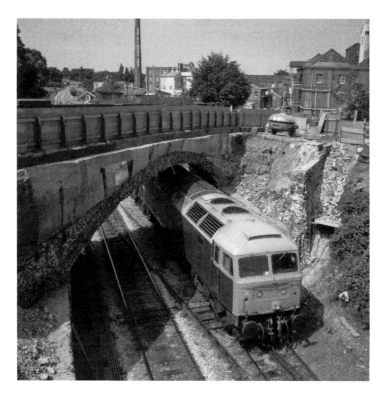

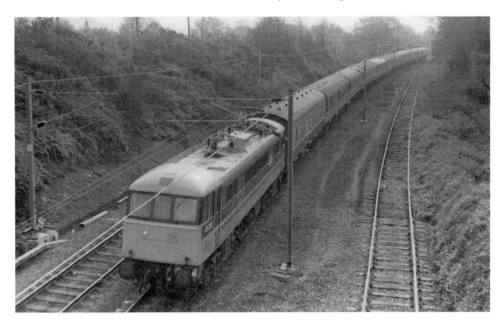

Electric locomotive No. 86255 hauls the Up 'Day Continental' boat train from Harwich International on the first day of full electric services on the branch. This view was taken at 07.50 on 12 May 1986. (ATW Collection)

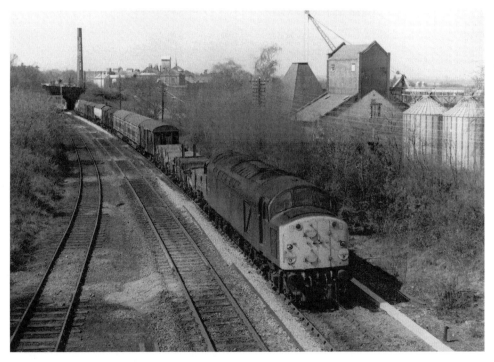

No. 40124 restarts after a signal check (due to awaiting clearance of a preceding DMU) whilst working the 21.35 Mossend to Parkeston ABS train on 15 April 1982. (ATW Collection)

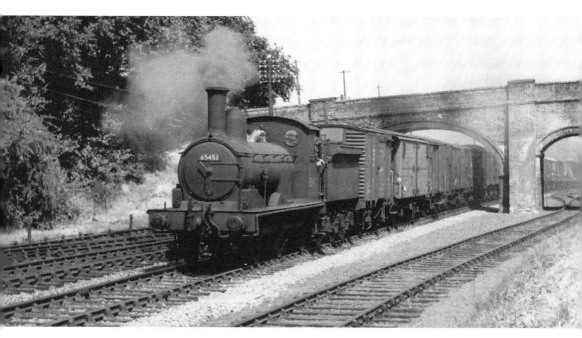

Veteran Class J15 locomotive No. 65453 works a westbound freight past the sidings at the station on 30 June 1951. (ATW Collection)

EMU No. 317326 makes the station stop on a local working on 16 August 2003. After electrification, the branch saw several different types of EMUs in use on local and through services including Class 308s, 309s, 312s, 317s, 321s and 360s. (ATW Collection)

The view from the Up platform looking towards Manningtree. The Down loop remains *in situ*, but the rest of the goods yard has disappeared having been sold off to the expanding adjacent industrial works. (Ray Bishop)

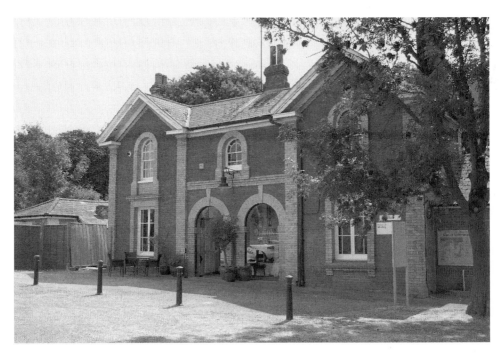

The tastefully restored main station is now a flat and a hairdresser. Potential train travellers must now purchase tickets from a platform ticket machine. (Ray Bishop)

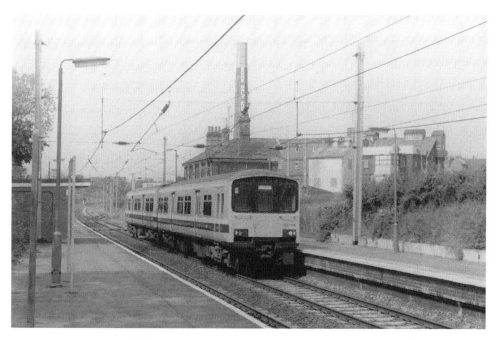

Sprinter services replaced the locomotive-hauled trains on cross-country services from May 1988. A two-coach service is seen in the platform, forming the 07.00 train from Derby to Harwich Parkeston Quay. (ATW Collection)

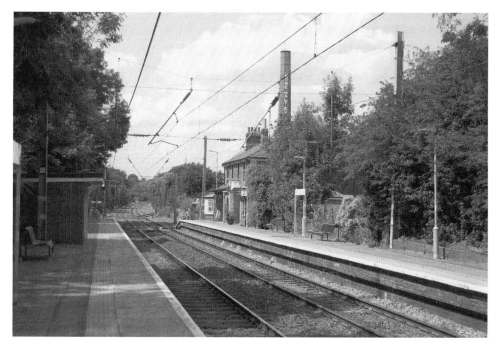

The view of the station seen from the Up platform, taken in August 2018. The familiar tall chimney of the adjacent maltings can be seen in the background. (Ray Bishop)

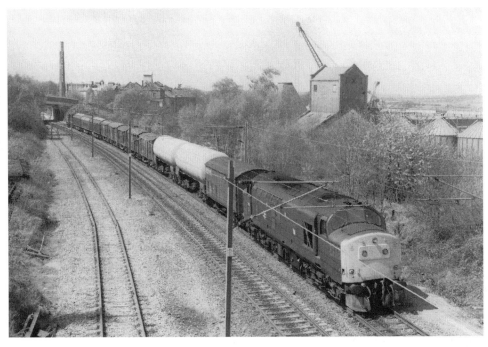

Locomotive No. 37178 works the overnight Mossend to Harwich Parkeston Quay freight train on 7 May 1986. By this time the Down siding had been lifted. (ATW Collection)

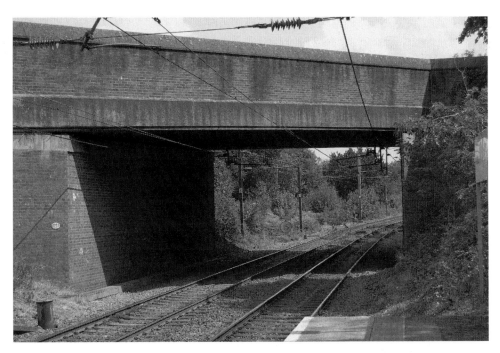

Standing at the Harwich end of the Up platform, the former connection to the Quay branch can be seen disappearing into the shrubs and trees. This view was taken in August 2018. (Ray Bishop)

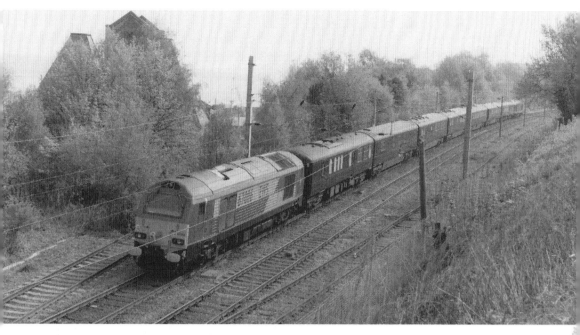

The 'Royal Train' departs from the station after dropping off the Prince of Wales, who was visiting the regeneration project based at the former maltings. Locomotives Nos 67005 and 67006 are working this special on 27 April 2004. (ATW Collection)

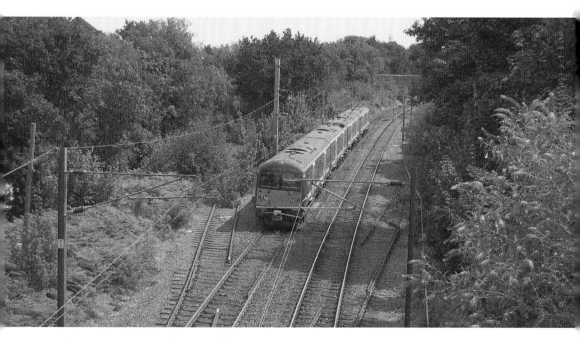

A Class 360 EMU accelerates away from the station, as seen from the adjacent road overbridge. The connections from the Up siding and to the former incline are shown as partially dismantled, as seen in August 2018. (Ray Bishop)

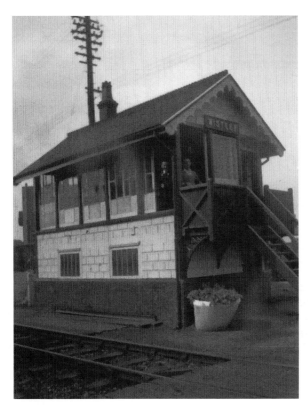

Left: Mistley signal box, including the signalman and another railwayman. The signal box had been provided in 1882 and was originally fitted with a twenty-seven-lever McKenzie & Holland frame that was later extended to thirty levers. The signal box closed on 29 September 1985, when the signalling was taken over by Colchester power signalling centre. (Alf Foster)

Below: The other regular type of EMU to use the branch are the Class 321s. Unit No. 321348 is seen arriving on a Down service in August 2018; these units are to be replaced in 2019. (Ray Bishop)

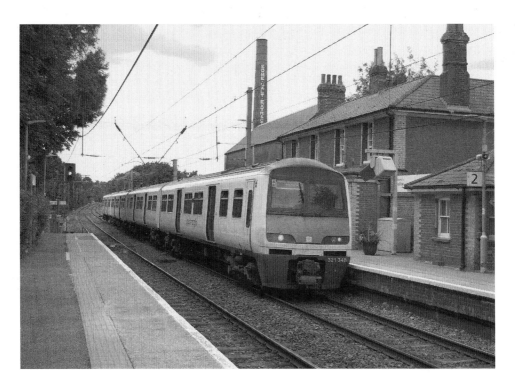

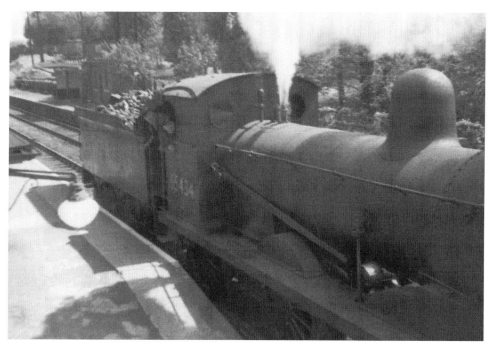

Class J15 locomotive No. 65434 is seen shunting at the station during the 1950s. The crew are looking up at the photographer. (Alf Foster)

Class N2 tank engines were tried on the branch in the 1950s. Here No. 69561 is just about to pass the signal box on a passenger working. (Alf Foster)

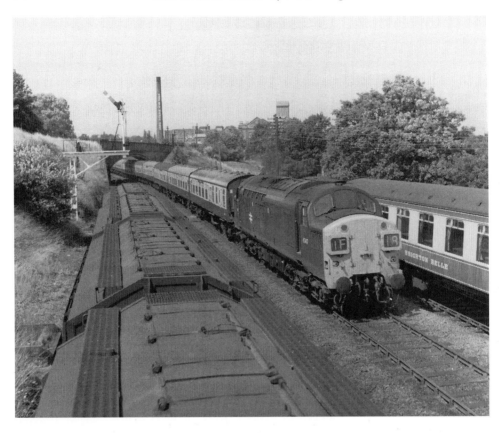

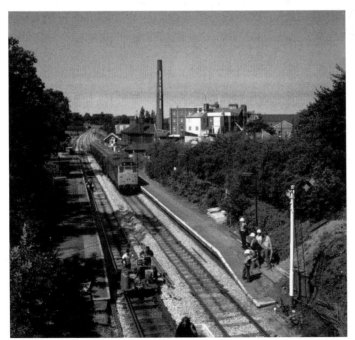

Above: Locomotive No. D6747 is seen accelerating away from the station with the Down 'Day Continental' boat train, passing ex-Brighton Belle rolling stock which was being stored in the down siding, on 16 July 1972. (ATW Collection)

Left: Brush Type 2 No. D5502 working the Down 'Day Continental' on 1 June 1969. The tall chimney dominates the skyline at this location. (ATW Collection)

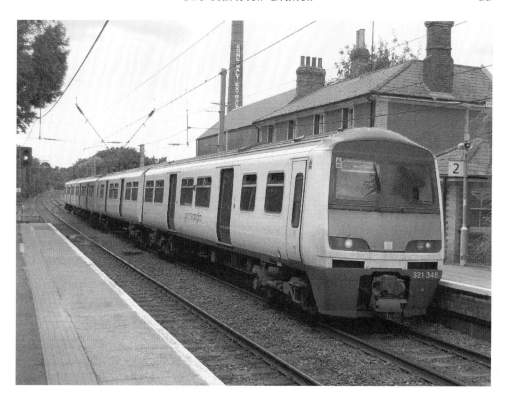

Above: EMU No. 321348 is seen working a Down service into the station during August 2018. Passengers arriving at the Up platform have to cross the line at the London end. The crossing is controlled by red/green miniature warning lights; there is no footbridge. (Ray Bishop)

Right: Seen from the adjacent road overbridge, a Class 37 is seen working an engineers' train eastbound towards Harwich. The River Stour can be seen in the background. (ATW Collection)

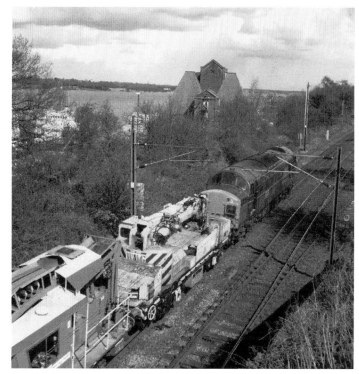

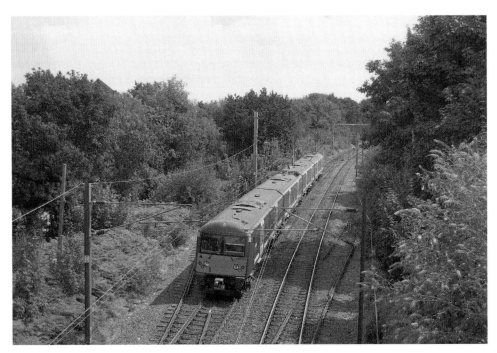

An elevated view of a Class 360 EMU passing the former junction to the quays. Tree growth dominates both sides of the line in this August 2018 view. (Ray Bishop)

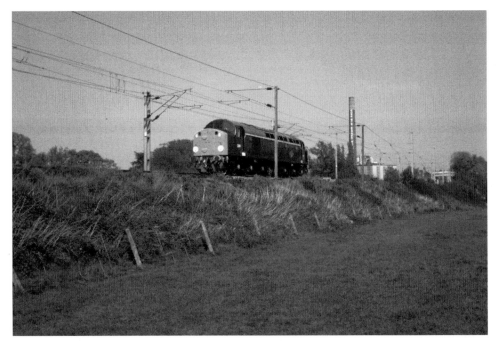

A Class 37 locomotive works light engine back towards Manningtree on a bright and sunny day in the 1990s. (ATW Collection)

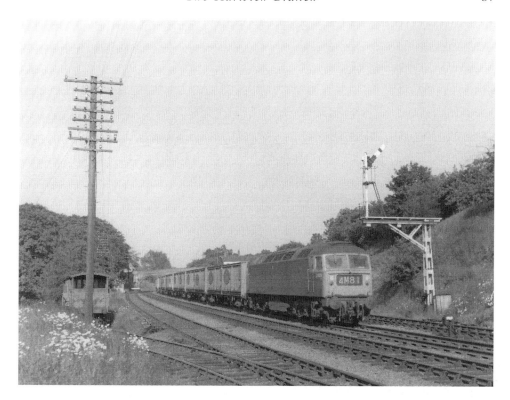

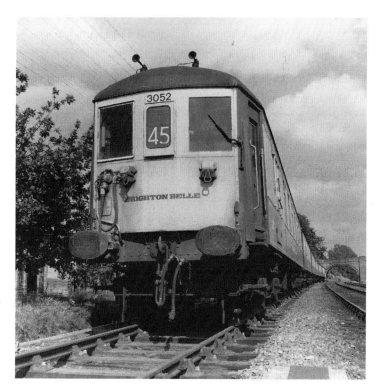

Above: Class 47 diesel locomotive No. D1889 passes the Up home signal with a Ford Freightliner train on 5 August 1972. On the left can be seen a brake van on the incline line to the quay. (ATW Collection)

Right: Brighton Belle withdrawn EMUs were stored in the Down siding, having been bought for further use by Allied Breweries. This front-end view is of unit No. 3052, which had arrived around 21 July of that year. (ATW Collection)

A Class 08 diesel shunter climbs the incline line back towards the main station with four grain wagons and a brake van. The line in the foreground led down to the quay itself. (Dr I. C. Allen/ Transport Treasury)

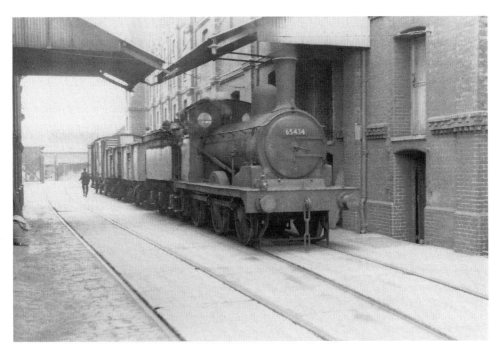

Class J15 locomotive No. 65434 is seen on the quayside with a short mixed freight train in the 1950s. (Dr I. C. Allen/Transport Treasury)

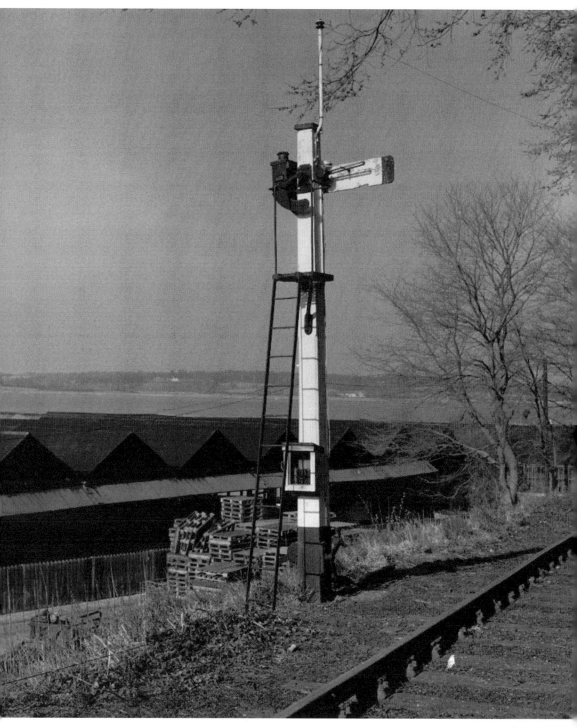

A close-up of Mistley Quay's incline line wooden semaphore home signal, seen from the trackside on 17 April 1976. Note the extension on the top of the post that took the telephone wire back to the pole route and onto the signal box. (ATW Collection)

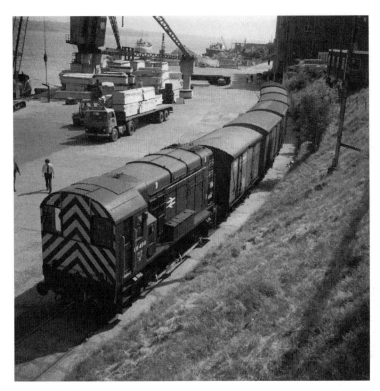

Class 08 No. 08498 is seen shunting vans at the quayside in the mid-1980s. Sadly all this traffic has been lost to road transportation. (ATW Collection)

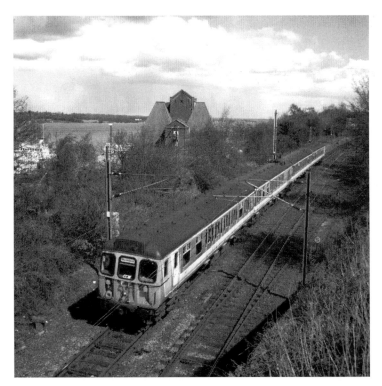

Class 312 EMU No. 312723 in Network SouthEast livery speeds away from the station stop whilst working the 14.10 Sunday service from Manningtree, en route to Harwich Town, 12 April 1998. (ATW Collection)

Bradfield

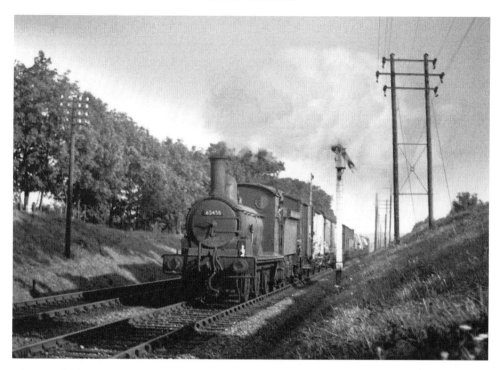

Class J15 locomotive No. 65438 is working a westbound local freight train between Bradfield and Mistley on a sunny 6 October 1951. (ATW Collection)

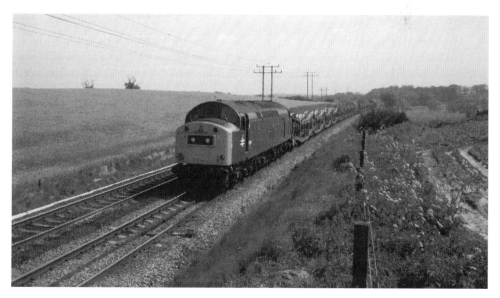

Class 37 Diesel No. 37077 on a car transporter stock working from Whitemoor to Harwich Parkeston Quay. It was seen on 6 June 1983. (ATW Collection)

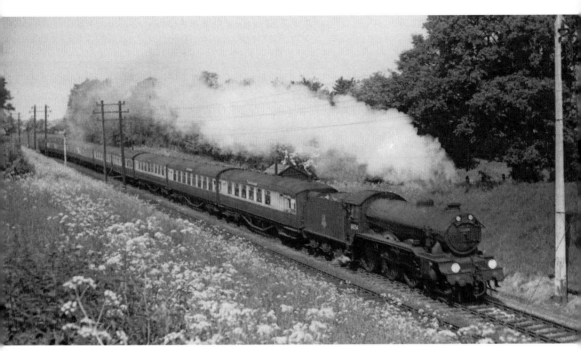

Class B17/4 steam locomotive No. 61654 *Sunderland* is seen working the 'Day Continental' boat train service on 24 May 1952. (ATW Collection)

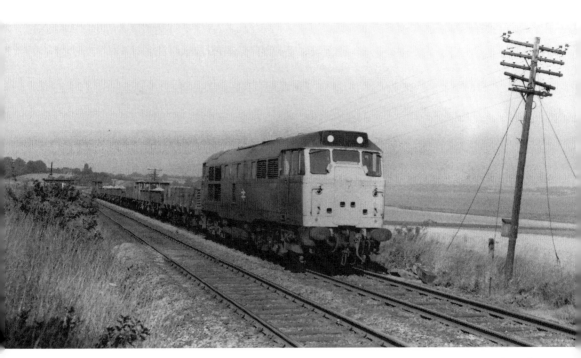

Class 31 No. 31321, working an engineers' spoil train, is seen close to the river passing a heavily stayed but still leaning telegraph pole on 22 July 1980. (ATW Collection)

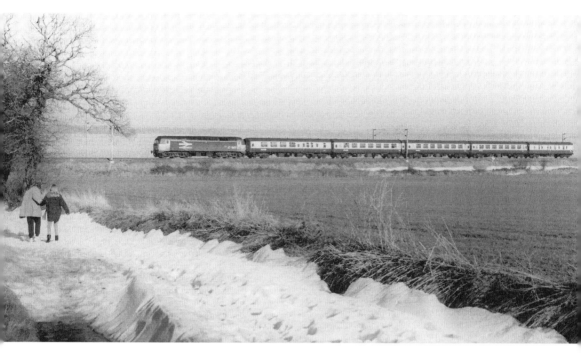

Surrounded by a wintry scene, diesel locomotive No. 47647 is seen working the 13.20 Harwich Parkeston Quay to Blackpool service near the old station on 31 January 1987. (ATW Collection)

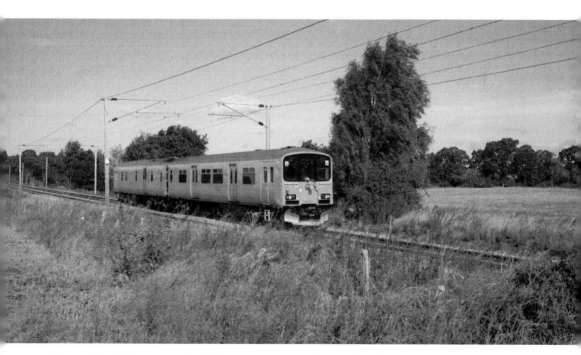

A Network Rail Departmental DMU on an engineers' train, near the old station on 4 September 2009. (ATW Collection)

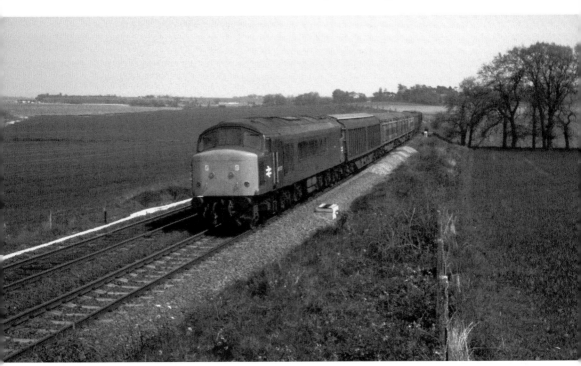

Diesel locomotive No. 45157 approaching the old station site as it works back towards its home territory with a Harwich Parkeston to Mossend freight train. (ATW Collection)

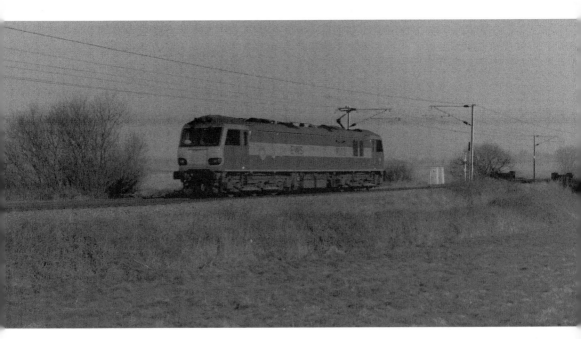

No. 92031 running light locomotive back to Wembley after working the 'Spinning Sparkey' rail tour to Harwich Town on 22 February 2003. (ATW Collection)

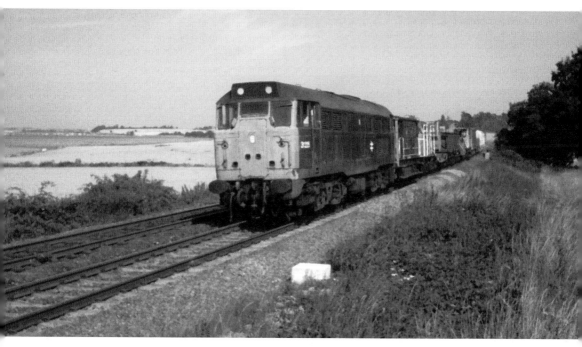

No. 31225 working an engineers' foundation train back to Ipswich yard on 29 July 1983, a sunny day. (ATW Collection)

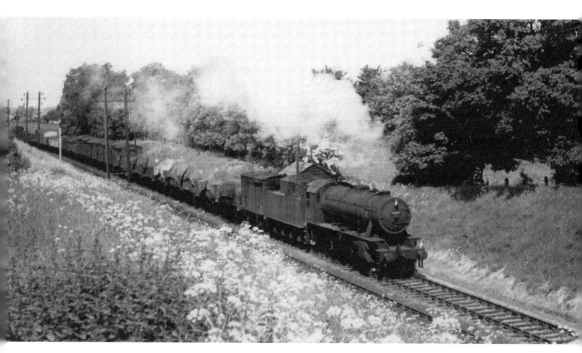

A WD Class 8F 2-8-0 working a long freight near to the station on 24 May 1952. (ATW Collection)

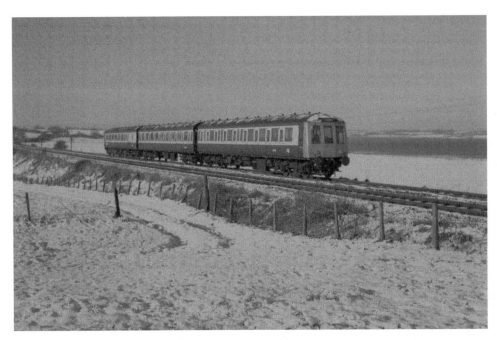

A three-car Class 125 DMU approaches the former station site, seen whilst working a local service on 12 December 1981. A weak winter sun, a blue sky and snow on the ground make for perfect conditions for photography. (ATW Collection)

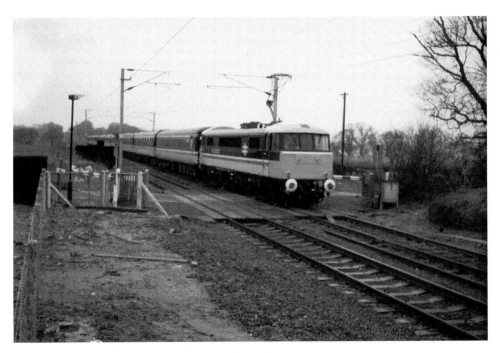

No. 86238 seen passing over Bradfield level crossing whilst working an additional boat train service to Harwich Parkeston Quay on 21 April 1986. (ATW Collection)

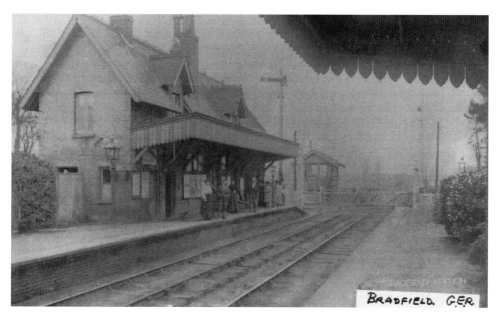

The sad sight of the former station buildings and house being demolished on 28 February 1986. The station had closed in 1956 but the buildings were used by the resident crossing keeper to operate the gates. (ATW Collection)

The station seen in happier times with passengers and staff posing for the camera in Great Eastern Railway days. The signal box was provided in 1882 and closed in 1924, its function being replaced by a ground frame. (Lens of Sutton Collection)

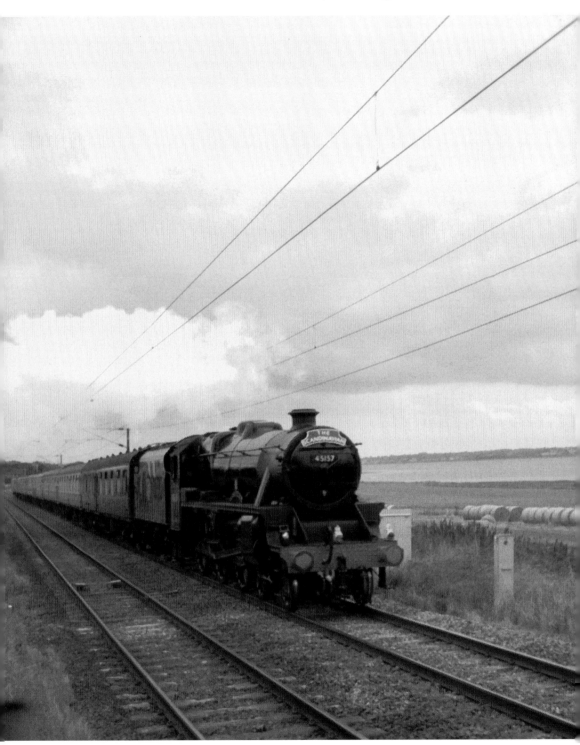

Black 5 steam locomotive No. 45157 working 'The Scandinavian' steam special, near the old station, on 3 August 2000. The River Stour can be seen in the background. (ATW Collection)

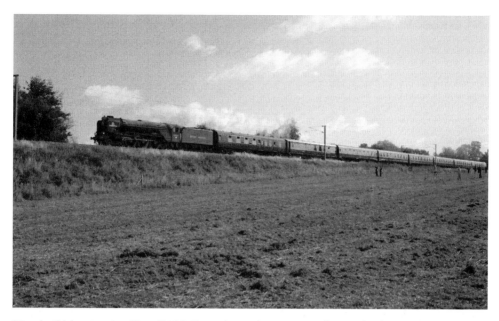

New-build locomotive No. 60139 *Tornado* working a special near the former station on the 4 September 2009. (ATW Collection)

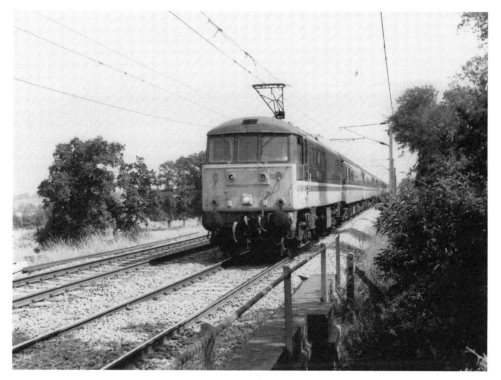

Electric locomotive No. 86223 working an Up boat train service from Harwich Parkeston Quay to London Liverpool Street on 14 August 1991. (ATW Collection)

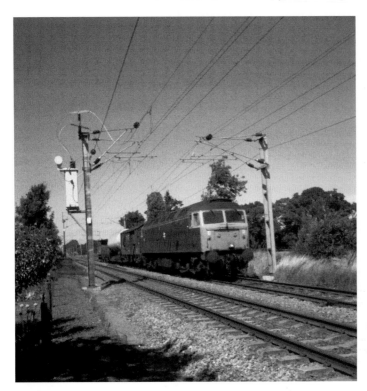

Left: Diesel locomotive No. 47319 is seen passing on a short freight working on 6 August 1986. Sadly the branch sees very little freight these days. (ATW Collection)

Below: The station site and level crossing. Full-width barriers had replaced the wooden gates prior to electrification of the branch. (ATW Collection)

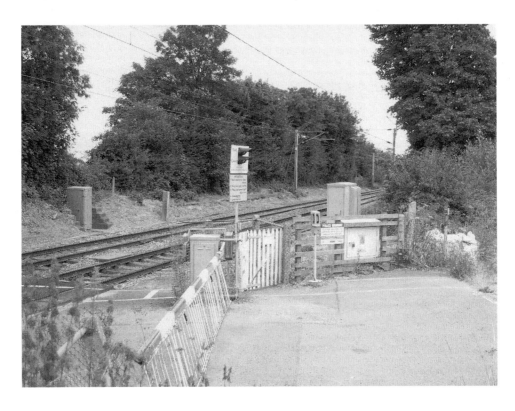

Priory Halt

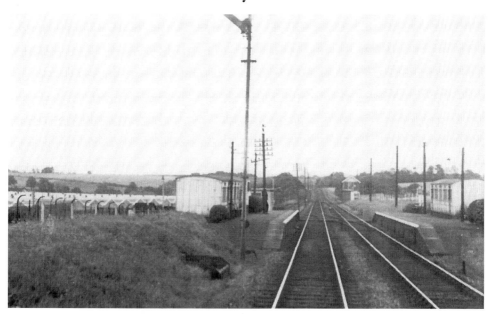

Priory Halt and signal box seen from a lineside view in 1957, looking towards Parkeston. The halt opened in 1914 to serve the Admiralty depot. The signal box was used from 1918 until 1966. The depot closed in 1964. (Stations UK)

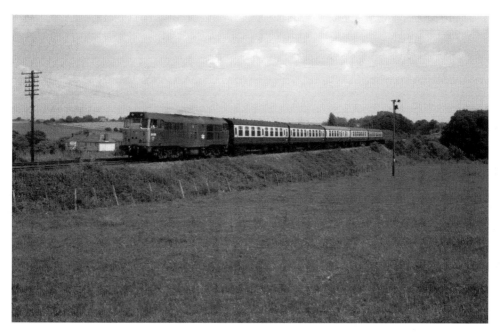

Diesel locomotive No. 31172, working the 12.40 Harwich Parkeston Quay to Peterborough service, passes the site of the old halt on Tuesday 2 June 1981. (ATW Collection)

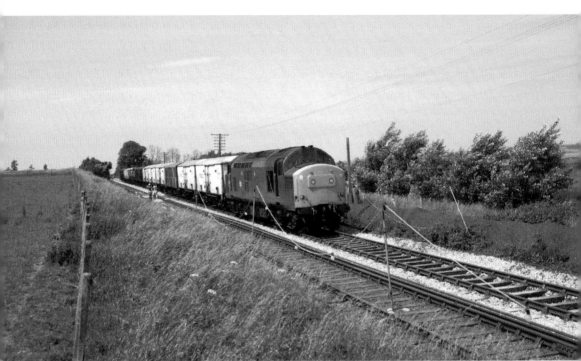

No. 37172 passing with the 21.35 Mossend to Harwich Parkeston Quay freight train on Wednesday 23 June 1981. (ATW Collection)

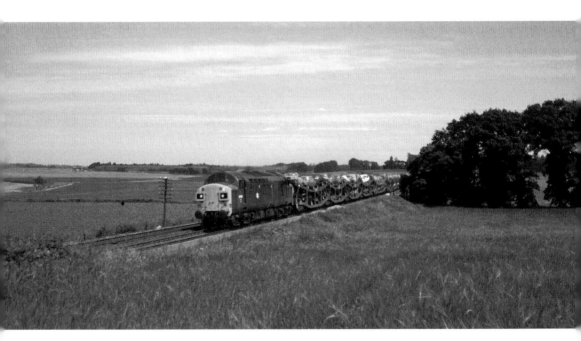

No. 37102 passes with the 14.25 Harwich Parkeston Quay to Bathgate car transporter train on Monday 22 June 1981. (ATW Collection)

Wrabness

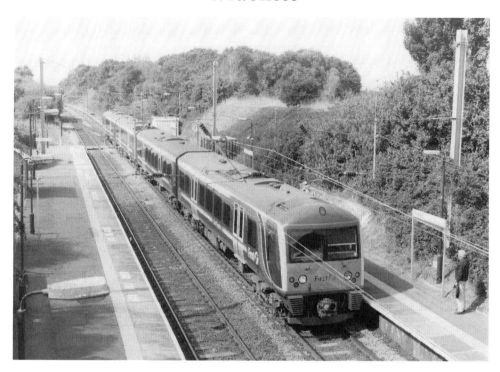

Electric multiple unit No. 360105, in First Great Eastern livery, arrives at the station with a Harwich town service on 3 September 2003. (ATW Collection)

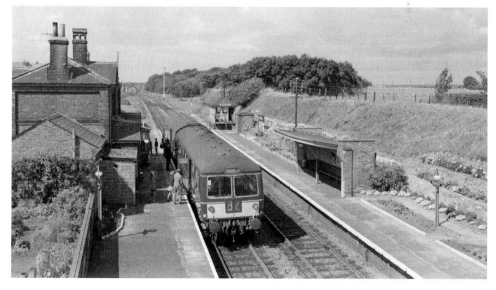

A Cravens Class 105 DMU calls at the station with 11.03 Harwich Town to Manningtree local service on 17 August 1967. The main station buildings were on the Up side. (ATW Collection)

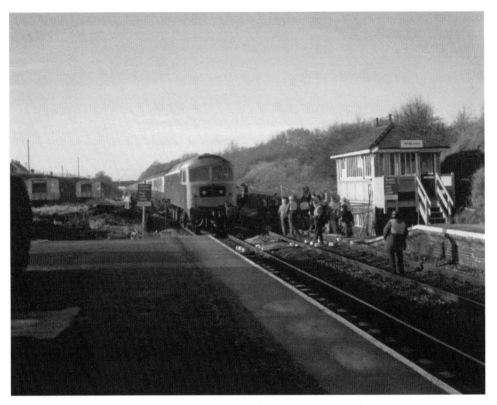

Locomotive No. 47577 working a Down boat train service over the Up line during single line working. This was caused by engineering works installing foundations for electrification masts. (ATW Collection)

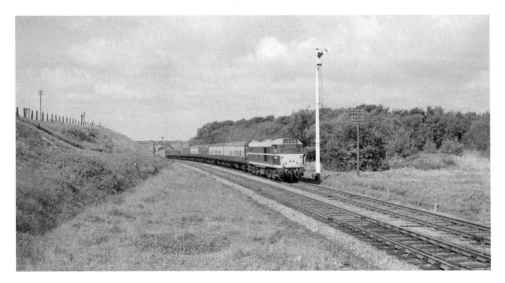

Type 2 diesel No. D5620, later designated Class 31, works a Down empty coaching stock train past the very tall Down home signal on 17 August 1967. (ATW Collection)

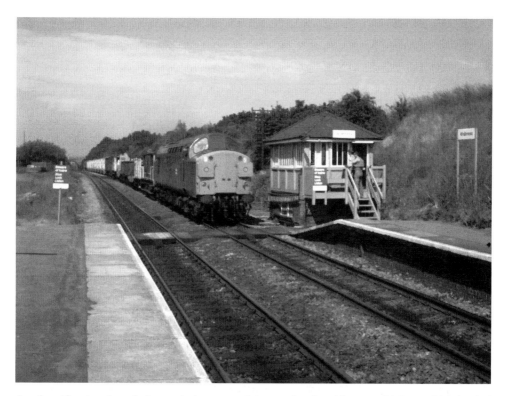

An electrification foundation train is seen arriving at the signal box on 21 June 1983, hauled by locomotive No. 37015. The engineers would take possession of one of the tracks during the day to dig the foundations and pour concrete. (ATW Collection)

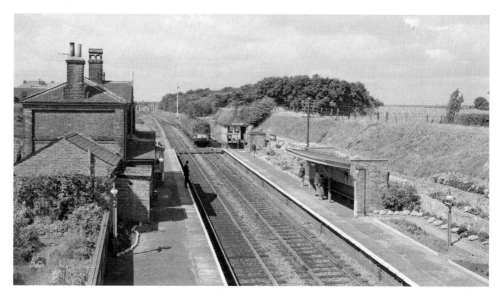

A Derby Lightweight type DMU is seen arriving on a Down service from Ipswich to Harwich Town in the 1960s. Note the tidy appearance of the station at this time. (ATW Collection)

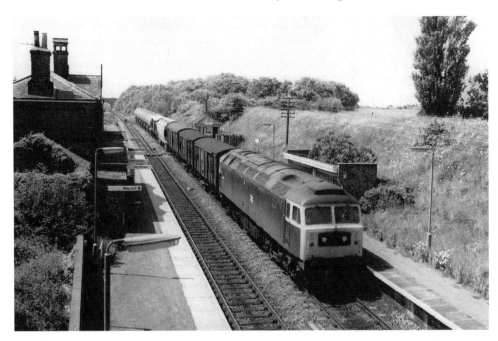

Class 47 diesel locomotive No. 47117 works a Harwich Parkeston Quay-bound freight train through the station on 1 July 1981. Notice the station gardens have now gone and small shrubs are growing on the roof of the waiting shelter. (ATW Collection)

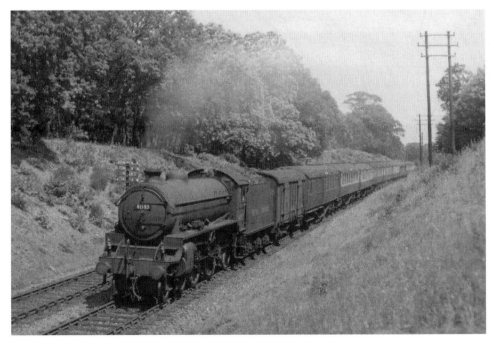

Class B1 steam locomotive No. 61192 works an Up boat train service, near to the station, on 8 July 1950. (ATW Collection)

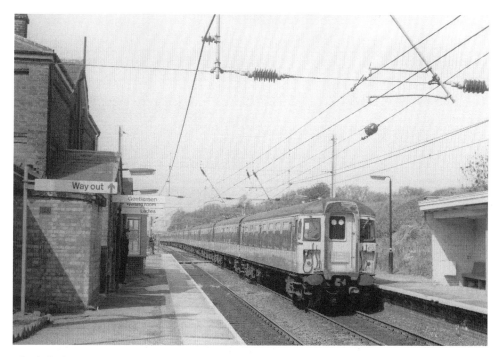

The full electric train service commenced on 12 May 1986. EMU No. 309613 is seen passing the station working a Down boat train service from Liverpool Street to Harwich Parkeston Quay. (ATW Collection)

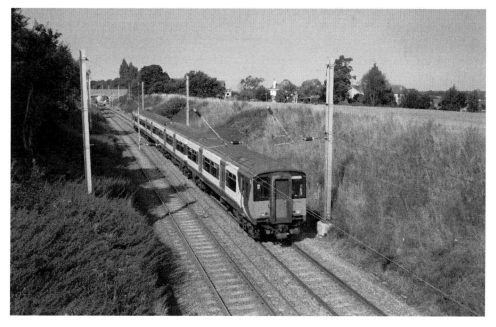

EMU No. 317655 accelerates away from the station on 25 August 2002. The platform can just be seen under the bridge. (ATW Collection)

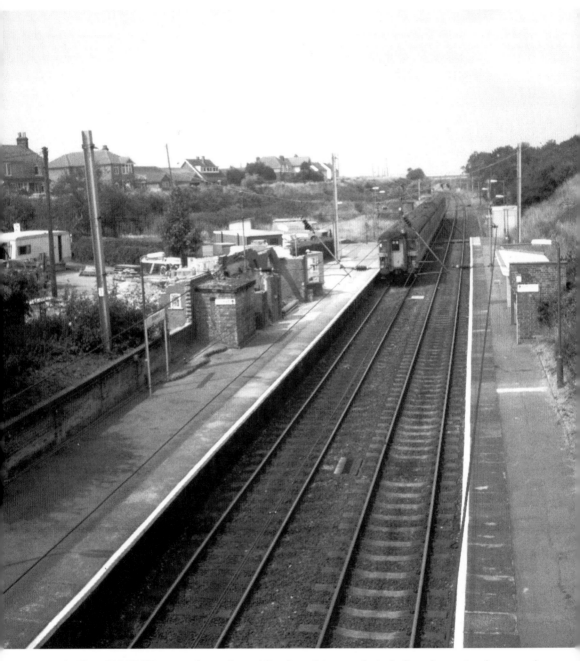

A Class 309 EMU passes the station whilst demolition work, including the station house and buildings, takes place. It was seen on 4 July 1989. (ATW Collection)

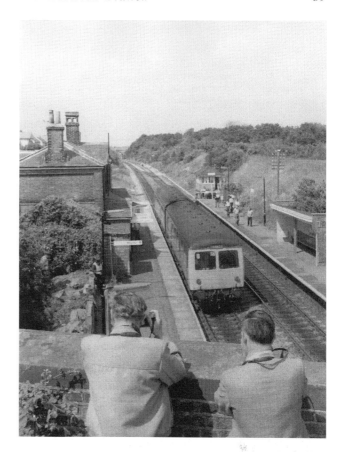

The photographer takes a picture of the photographers taking a picture of a Cravens Class 105 type DMU arriving on an Up local service on 28 June 1983. (ATW Collection)

The sad site of the station buildings and house being demolished; at least the bricks are being recycled. This was the scene on 4 July 1989. (ATW Collection)

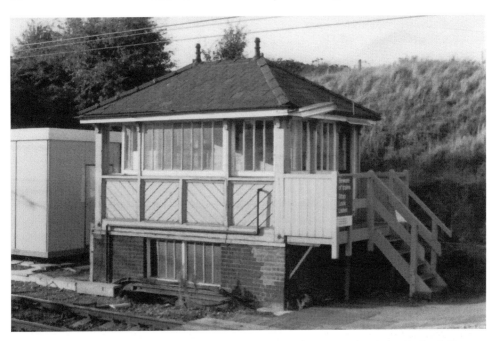

The closed signal box, seen in September 1985. It contained a twenty-five-lever Saxby & Farmer frame. The signal box lives on at the Colne Valley Railway, where it once again signals trains. (Andy Wallis)

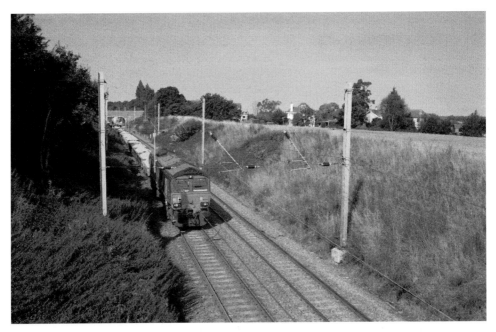

Modern diesel locomotive No. 66046 is seen near to the station working an engineers' ballast train on 25 August 2002. The station platforms can be seen through the bridge in the distance. (ATW Collection)

The bracketed Up starting signal is seen off so a Cravens DMU can pass with a local service to Manningtree during 1966. (Dickie Pearce)

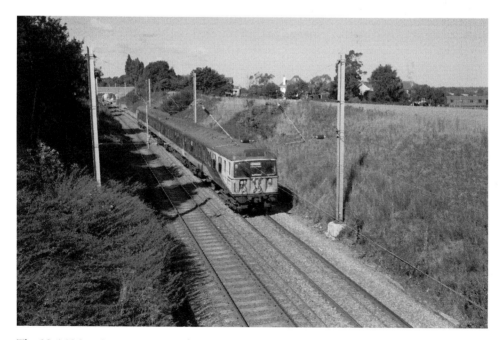

The 09.46 Manningtree to Harwich Town service is seen leaving the station on 30 August 2003. This is a Class 312. Since electrification, various classes of EMUs have come and gone from the branch. (ATW Collection)

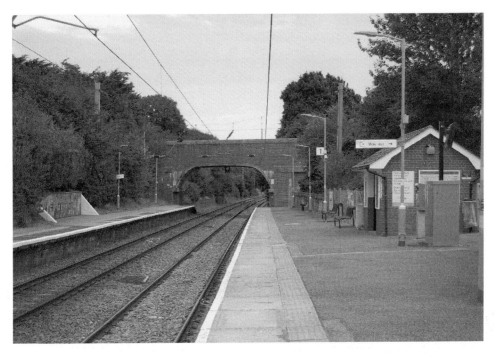

The station, today with a replacement brick shelter. There are no staff and train information is provided on indicator boards. (Ray Bishop)

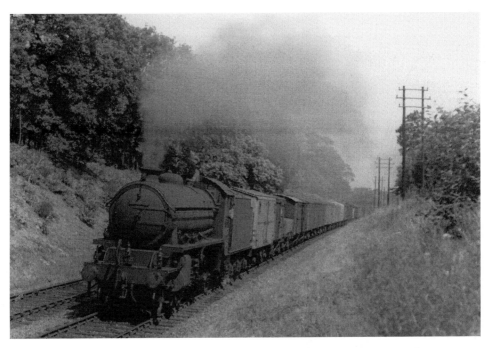

This Class K1 steam locomotive is working a heavy continental goods train near the station, en route to Whitemoor Yard. It was seen on 8 July 1950. (ATW Collection)

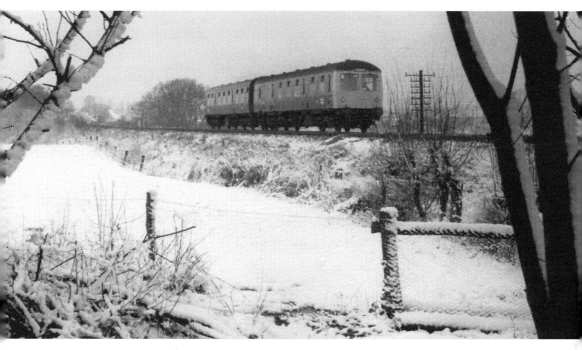

The 09.45 Manningtree to Harwich town shuttle service DMU is seen near Wrabness after snowfall on 10 February 1983. (ATW Collection)

The 14.12 Harwich Town to Liverpool Street electric service crosses back onto the Up line after being diverted from Harwich Parkeston Quay. This was due to a landslip on the Up line caused by heavy rainfall. The date was 20 August 1987. (ATW Collection)

EMU No. 321342 slows to call at the station. The buildings and waiting shelter have all now gone, with just a bus stop-like shelter now provided. (ATW Collection)

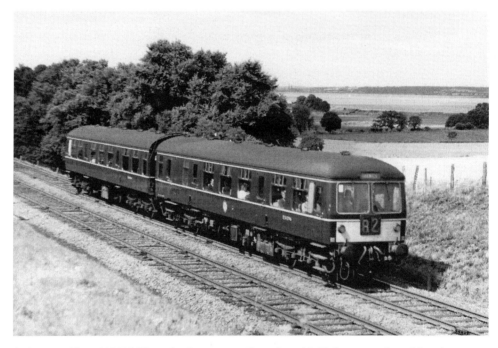

A Cravens Class 105 DMU works the summer Saturdays 12.02 departure from Manningtree to Harwich Town. It is seen near to the station on 5 August 1967. (ATW Collection)

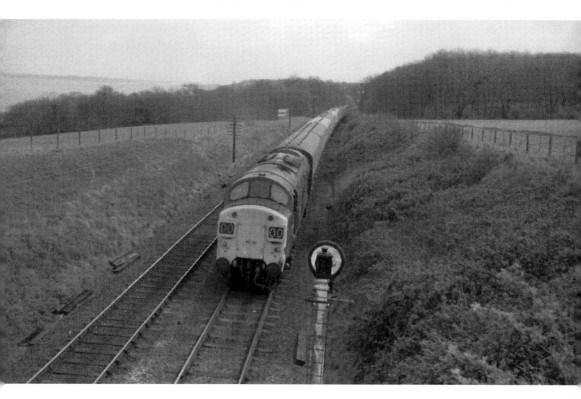

Above: This Class 37 diesel
locomotive is seen passing
the station's Up home
banner repeater signal whilst
working the Up Esbjerg boat
train to Liverpool Street.
(ATW Collection)

Right: This redundant telegraph
pole is readied for felling as a
Class 37 diesel approaches on
28 June 1983. (ATW Collection)

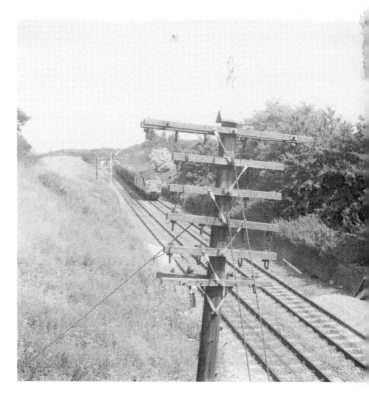

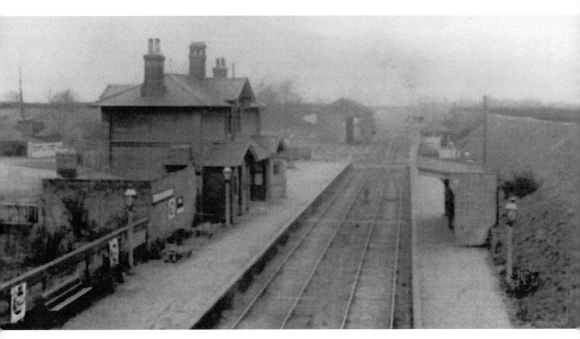

A Great Eastern Railway view from the station road overbridge looking at the main buildings, goods yard and signal box. Note the platform starting signal is on the wrong side for Up trains. (Lens of Sutton Collection)

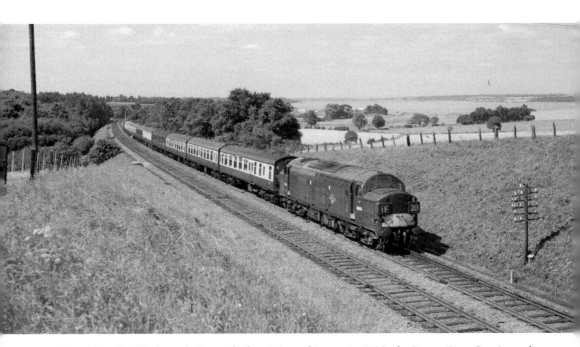

Diesel No. D6700, later designated Class 37, working train 1F20, the Down 'Day Continental' boat train service, to Harwich Parkeston Quay. It is seen here approaching the station on 20 August 1967. (ATW Collection)

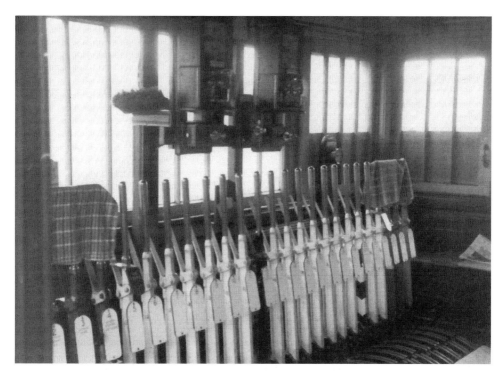

Wrabness station signal box lever frame, seen in 1965 after the goods yard and sidings had been closed and lifted. At this time only nine levers worked out of the original twenty-five. (Dickie Pearce)

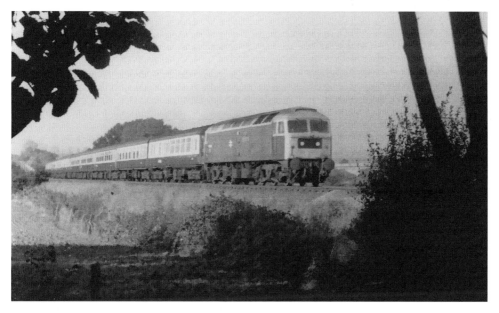

Bordered by trees, locomotive No. 47580 *County of Essex* is seen working the Down 'Day Continental' boat train service on 15 October 1982. (ATW Collection)

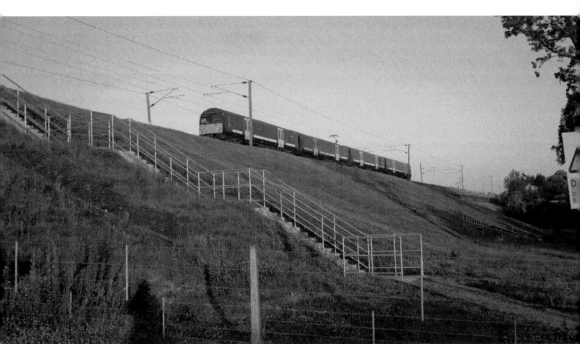

A Class 360 EMU passes a public footpath crossing near to the station on 24 June 2009. Note the handrails and steps plus warning signs. (ATW Collection)

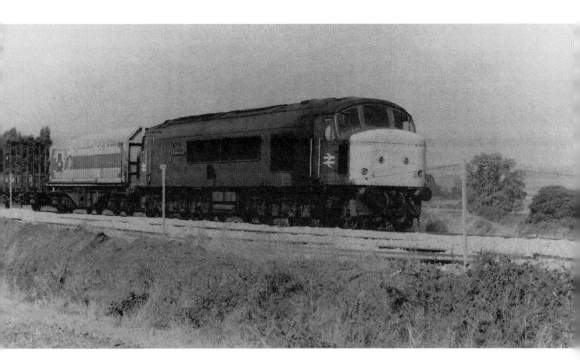

Diesel No. 45041 working a Whitemoor to Parkeston freight near the station on 15 August 1983. (ATW Collection)

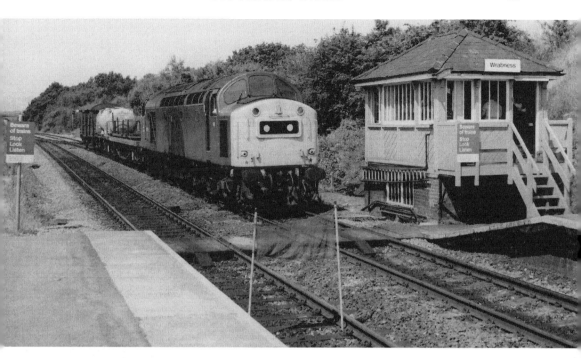

A Mondays only Whitemoor to Parkeston freight passes the signal box on 4 July 1983. Note the banner across the Up line, which was closed for engineering work. (ATW Collection)

A Class N7 locomotive working a three-coach local passenger near the station on 8 September 1956. (ATW Collection)

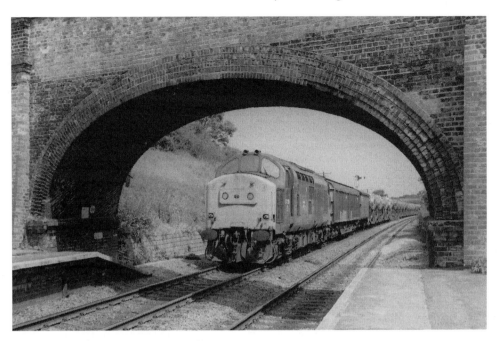

Locomotive No. 37226 working the 14.10 Harwich Parkeston Quay to Mossend freight train service. It is seen approaching the station on the wrong line due to ongoing electrification works. The date is 21 June 1983. (ATW Collection)

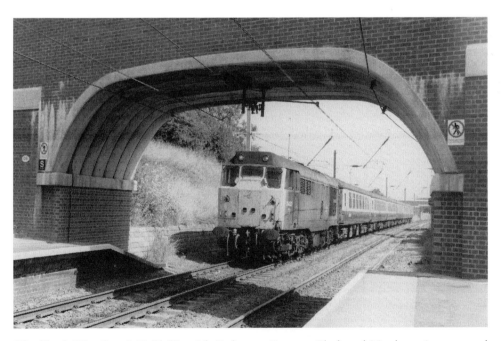

'The North West Dane' 13.20 Harwich Parkeston Quay to Blackpool North service, powered by No. 31432, is seen on 21 August 1987. It is working on the wrong line due to a weakened embankment. Note that the bridge has been raised for electrification clearances. (ATW Collection)

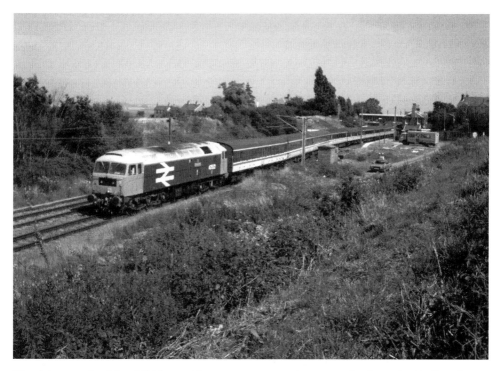

Diesel locomotive No. 47015, working a passenger train, crosses back to the Up line during single line working on 20 August 1987. (ATW Collection)

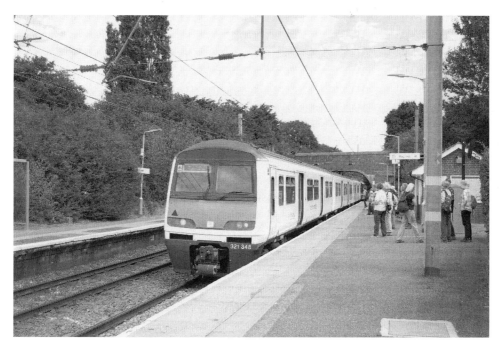

A Class 321 EMU arrives at the platform in August 2018. (Ray Bishop)

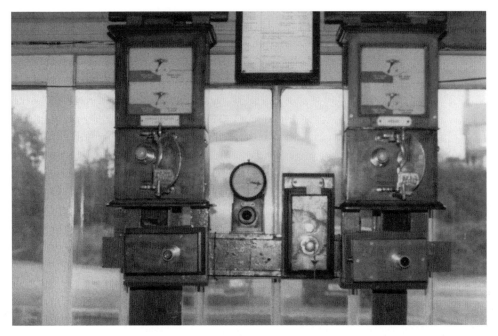

A close-up of the Tyers two-position block instruments in the signal box. These were used to signal trains between Parkeston Goods Junction and Mistley. The signal box was normally only open from Monday to Friday for early and late turns and closed at night and at weekends. (CVRPL Collection)

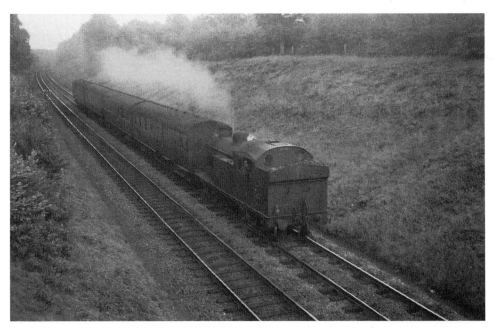

An N7 on the 11.27 Manningtree to Harwich Town local passenger service, seen during August 1956. (ATW Collection)

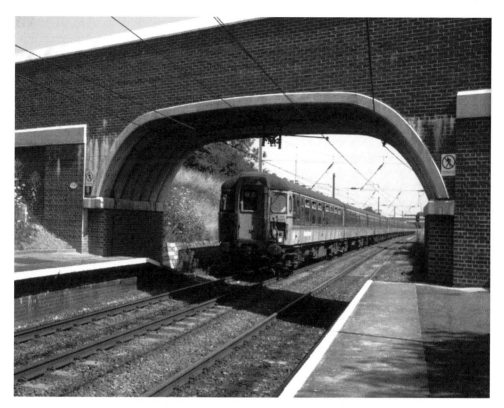

A twelve-car Class 309 EMU works an Up boat train service over the wrong line due to the Up line being closed for repairs to an embankment. The date is 21 August 1987. (ATW Collection)

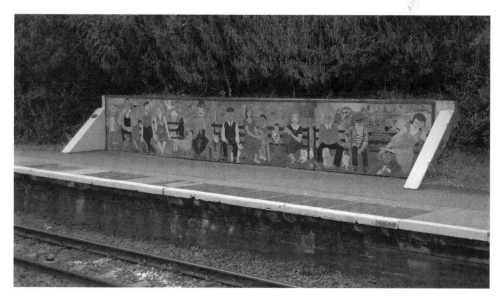

All that remains of the former platform shelter, now tastefully decorated with a mural. It is seen during August 2018. (Ray Bishop)

Left: The station railman doing his weekly task of changing the oil lamps for the Up starting signal. This view was taken in June 1983. (ATW Collection)

Below: The signal box is long gone with all the signalling functions now worked from Parkeston panel, which also controls the emergency facing and trailing crossovers seen in the background. Passengers have to cross the line at the end of the platform, aided by miniature red and green warning lights. (Ray Bishop)

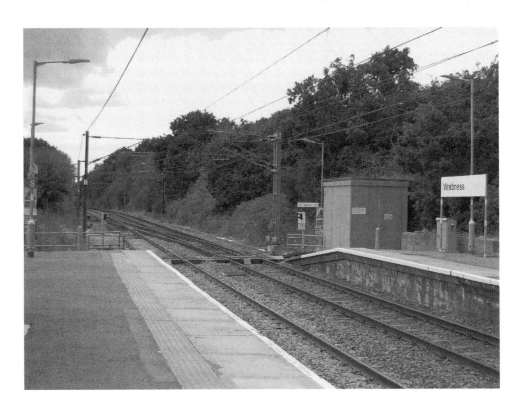

Harwich International 1995 to Present (Parkeston Quay 1882–1934, Harwich Parkeston West 1934–1972, Harwich Parkeston Quay 1934–1995)

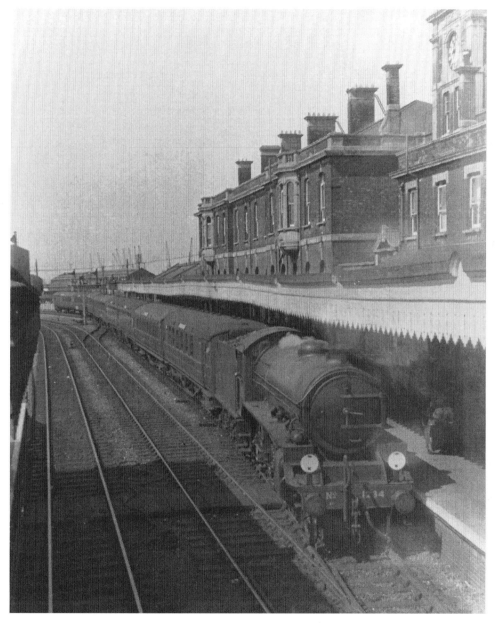

Still in LNER livery, Class B1 locomotive No. 1234 is seen arriving at the station with a boat train service from Liverpool Street on 29 August 1948. (ATW Collection)

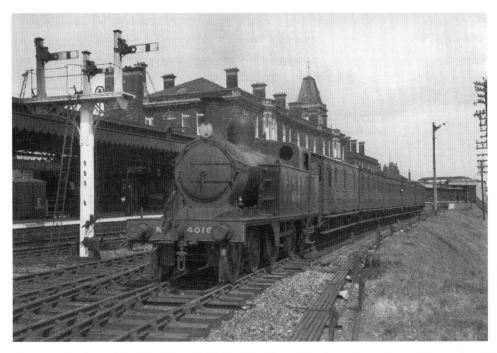

An undated view of LNER Class C12 No. 4016 departing from the station with a rake of elderly coaches. (Dr I. C. Allen/Transport Treasury)

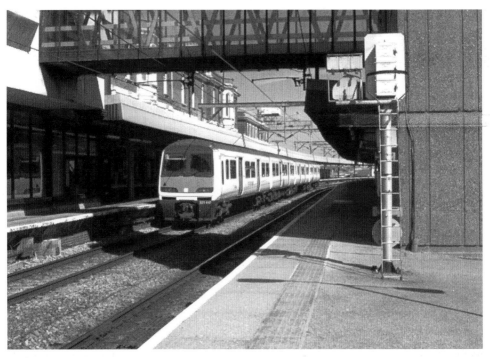

A Class 321 EMU is seen standing in the platform waiting its next turn of duty. (Ray Bishop)

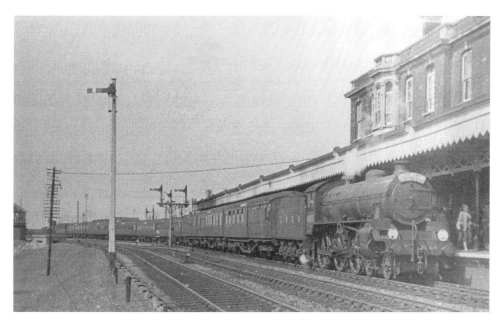

Class B1 locomotive No. 1005 is seen shunting empty stock out of the station into the carriage sidings on 29 August 1948. The locomotive is still in LNER livery, some eight months after the creation of British Railways. (ATW Collection)

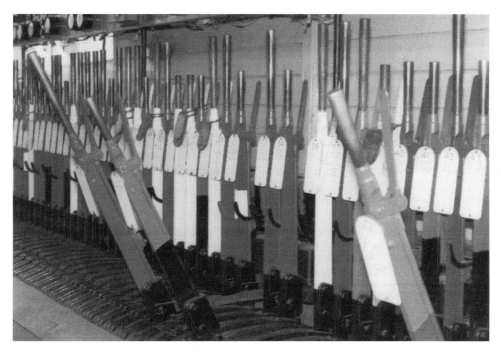

Part of the fifty-lever signalling frame in Parkeston West signal box. By this time all the points had been converted to power operation. The shortened handles tell the signalman that it is power-operated and does not need a heavy pull. (CVRPL Collection)

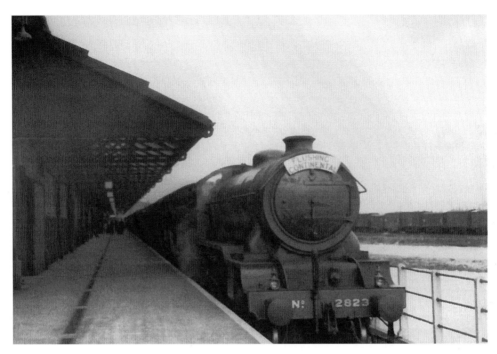

LNER Class B12 locomotive No. 2823 waits to depart with the 'Flushing Continental' boat train service from Parkeston Quay West, seen in 1938. (Stations UK)

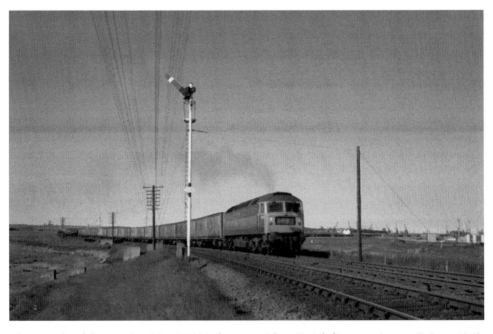

Class 47 diesel locomotive No. D1888 departs with a Freightliner service on 7 June 1969. Container traffic grew from around 30,000 units to over 100,000 by 1973. Levels of traffic fell from 1986 when most business was concentrated in nearby Felixstowe. (ATW Collection)

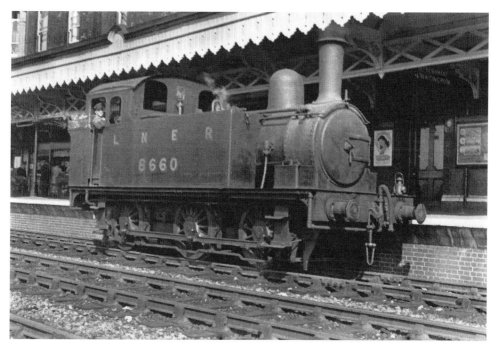

A Class J68 tank engine acts as station shunter on 29 August 1948. This locomotive is in LNER livery prior to being repainted and given the number 68660. (ATW Collection)

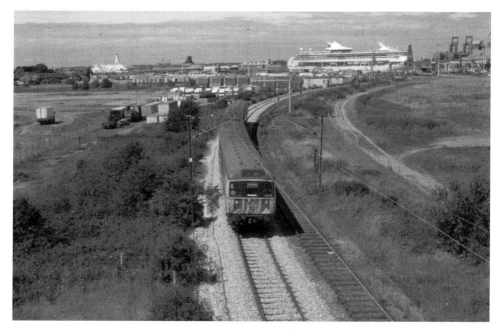

EMU No. 312711 is seen arriving at the station whilst working the branch shuttle between Manningtree and Harwich Town. This train was the 13.15 departure from Harwich Town. (ATW Collection)

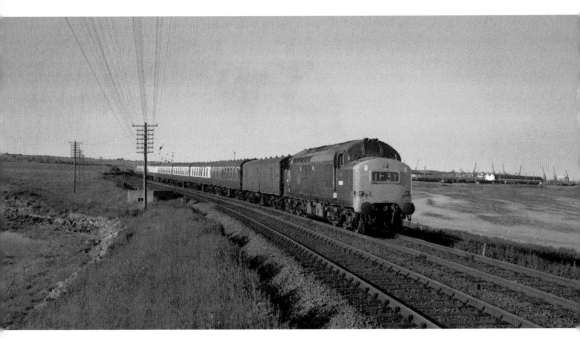

On a clear summer's day Class 37 diesel No. D6967 is seen working train 1F31, the Up 'Day Continental' service, on 7 June 1969. Note the splendid telegraph pole route, sadly now all gone. (ATW Collection)

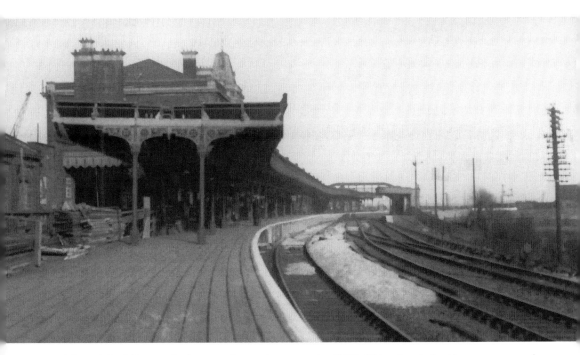

The original Down platform at the station, seen in 1933. This view is looking east towards Harwich. (RAS N642)

Right: On 11 August 2001, EMU No. 312711 was in charge of the branch shuttle service between Manningtree and Harwich Town. It is seen here passing the Freightliner depot, where weeds seem to be taking hold. (ATW Collection)

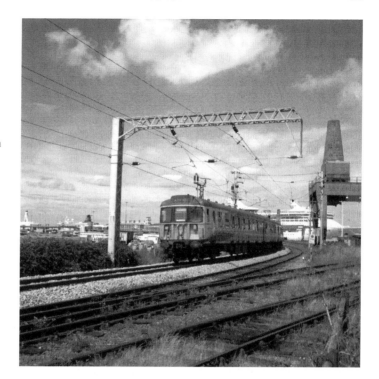

Below: A Class B12/3 locomotive works an Ipswich to Harwich Town train into the station on 29 August 1948. (ATW Collection)

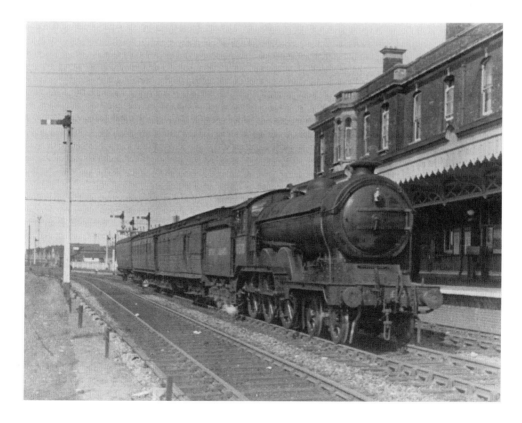

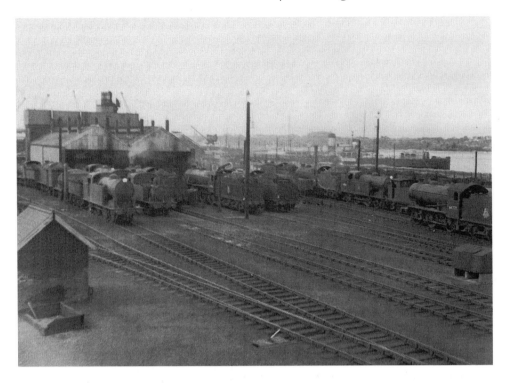

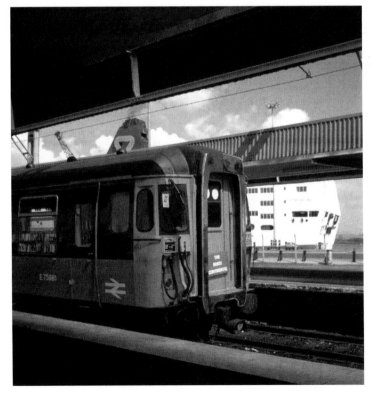

Above: An elevated view from an adjacent signal of Parkeston steam locomotive shed, as seen on 6 April 1950. At this time the depot had an allocation of twenty-eight engines ranging from B1s to J15s. (Alf Foster)

Left: EMU No. 309616 is seen working the 'Essex Continental' boat train service with the ferry *St Nicholas* featured in the background. This view was taken on 16 May 1986. (ATW Collection)

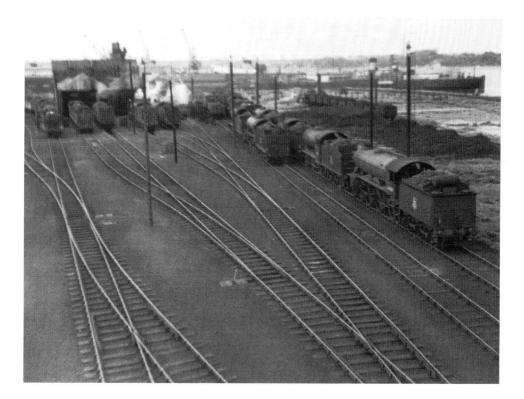

Above: An elevated view of Harwich Parkeston steam locomotive depot, designated as shed code 30F by British Railways. A ferry can be seen at the quay in the background. (Alf Foster)

Right: Class 08 diesel shunter No. 08956 is seen adjacent to a semaphore signal on 15 March 1983. (ATW Collection)

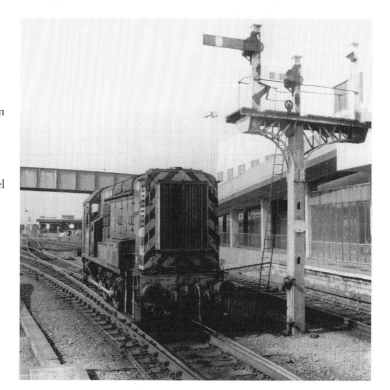

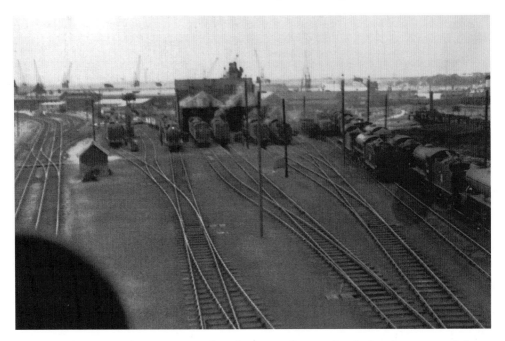

Five years later a similar view was taken from an adjacent signal. On the extreme left are the Up and Down main lines. The allocation of twelve B1s were used on the principle boat train services. (Alf Foster)

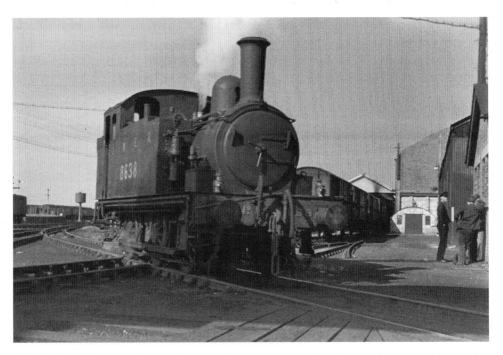

LNER Class J69 steam locomotive No. 8638 is seen in the sidings adjacent to the station in 1948. (ATW Collection)

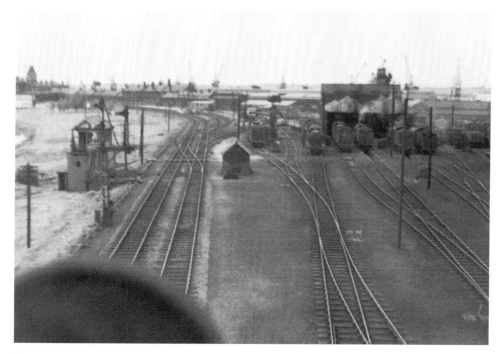

In this elevated view Parkeston East signal box can be seen. This signal box controlled all the eastern end of the station between its opening in 1882 and its closure in August 1968. It was equipped with a thirty-six-lever McKenzie & Holland frame. The adjacent engine shed closed on 31 January 1967. (Alf Foster)

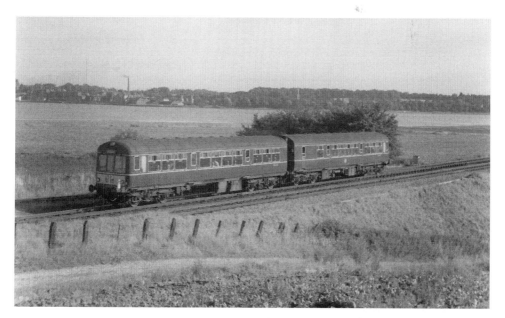

A Class 109 Wickhams type DMU is seen on the branch adjacent to the River Stour. These units operated from the mid-1950s until 1971. (ATW Collection)

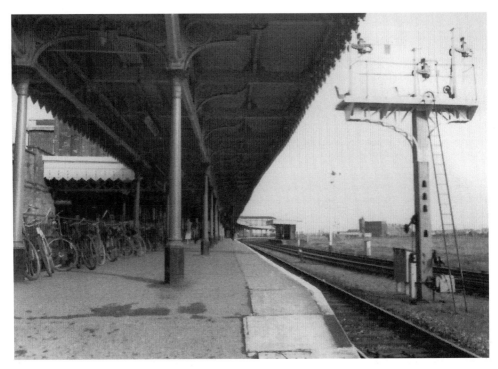

A general view of the station, seen in 1961. This was taken from the platform ramp looking east. Originally the Up platform was a lot shorter. (Stations UK)

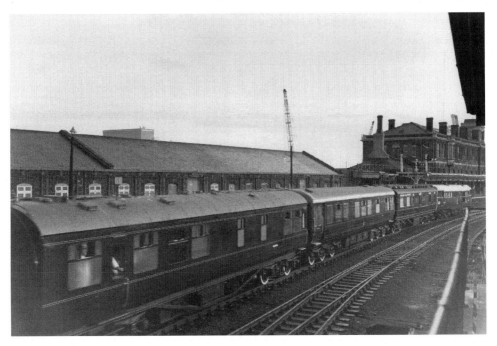

The 'Royal Train' is seen arriving at the station on 4 December 1969. (ATW Collection)

Further along the Down platform and under the canopy. The station was built on reclaimed land. (Stations UK)

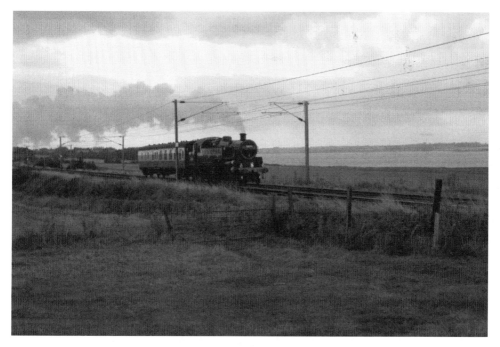

A Standard 4 tank engine plus support coach does a proving run across the branch, prior to working a special train. The River Stour can be seen in the background. (ATW Collection)

This westwards view along the main Down platform shows the shorter Up platform. The platforms were later rebuilt with the centre siding removed. This is a 1957 view. (Stations UK)

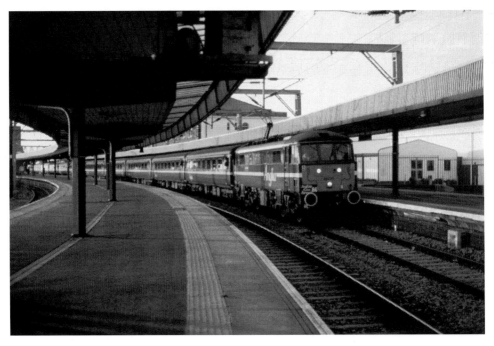

A Class 86 arrives at the station with a special train celebrating the withdrawal of the Class 86 electric engines from the area. (Ray Bishop)

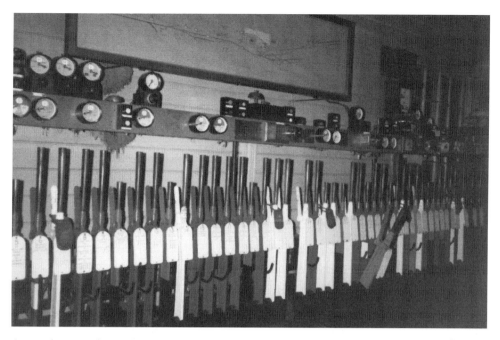

An inside view of part of the lever frame in the west signal box in 1970. Forty-three of the fifty levers were working. The box opened in 1934 and closed on 1 December 1985 when a new panel was brought into use. (CVRPL Collection)

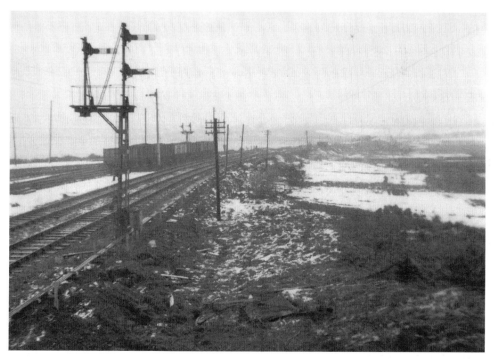

A snowy scene seen from Parkeston East signal box, looking towards Harwich. (Alf Foster)

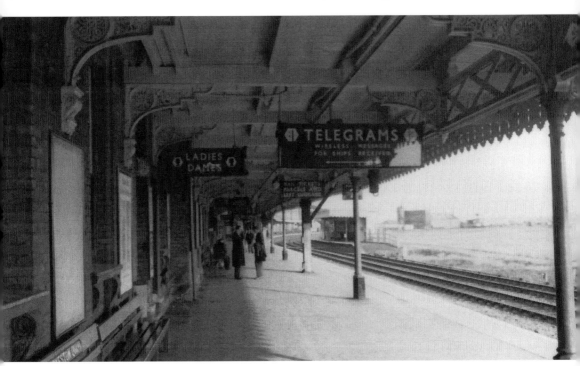

Under a canopy looking east before any alterations were made to the layout. This photograph was taken in 1961. (Stations UK)

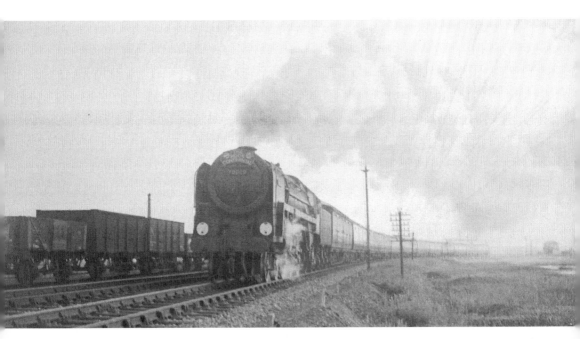

Class 7MT locomotive No. 70000 *Britannia* departs from the station with the Up 'Hook Continental' boat train to Liverpool Street on 26 July 1953. (ATW Collection)

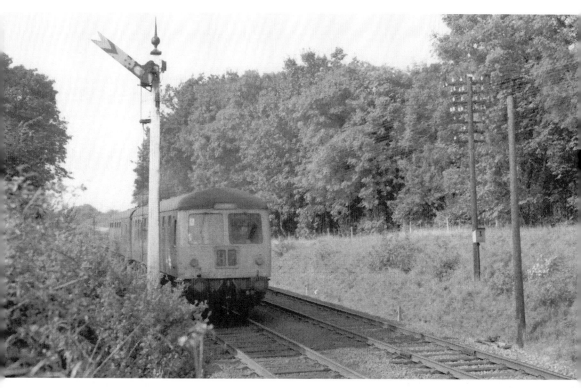

A rear view of a Cravens type DMU passing a semaphore distant signal on the Harwich branch. Although undated, the view would have been between 1956 and the early 1980s. (Dr I. C. Allen/ Transport Treasury)

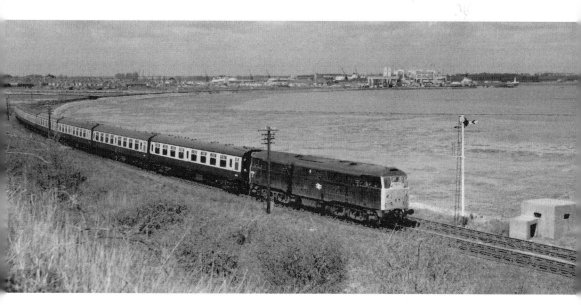

An unidentified Class 31 diesel working a cross country service to Harwich Town. It is seen skirting round Dovercourt Bay as it passes the Down distant signal. (ATW Collection)

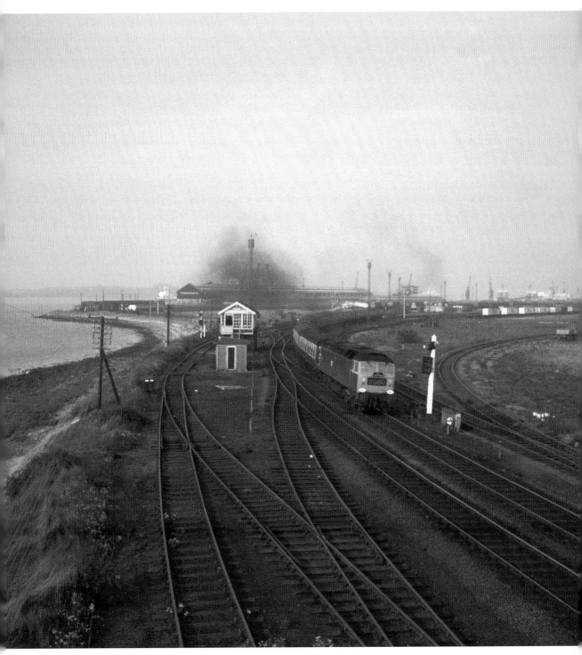

Class 47 diesel No. 47351 powers away from the station past Parkeston Goods Junction signal box on 8 May 1976. Part of the port's facilities can be seen in the background. (ATW Collection)

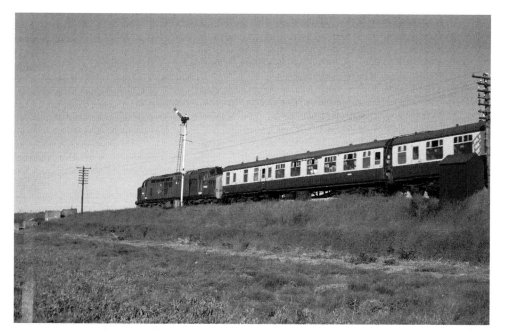

Class 37 diesel No. D6967 is seen working the Up 'Day Continental' boat train to Liverpool Street on 7 June 1969. (ATW Collection)

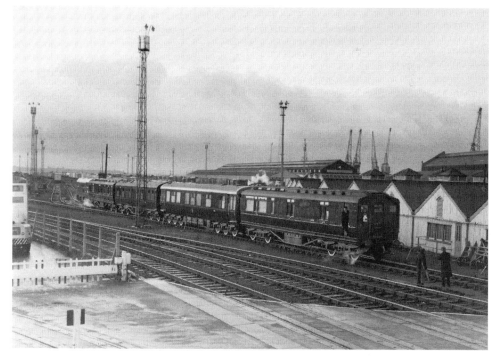

The empty 'Royal Train' is hauled into the sidings for servicing in December 1969. (ATW Collection)

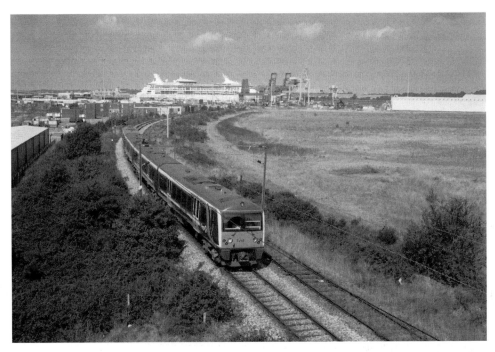

Class 360 EMU No. 360105 is seen working the 11.46 Manningtree to Harwich Town local service on 4 September 2003. A modern-day large ferry can be seen in the background (ATW Collection)

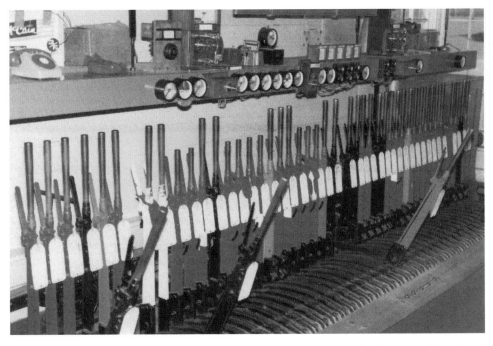

Part of the lever frame in Parkeston Goods Junction signal box. In its day this was a busy signal box. Now it is sadly part of history. (CVRPL Collection)

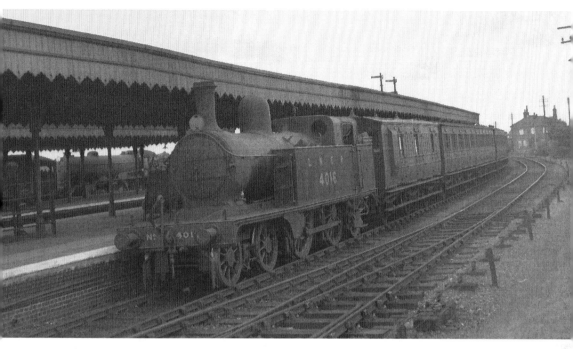

LNER Class C12 locomotive No. 4016 is seen in the platform with a rake of elderly coaches waiting for its departure time. (Dr I. C. Allen/Transport Treasury)

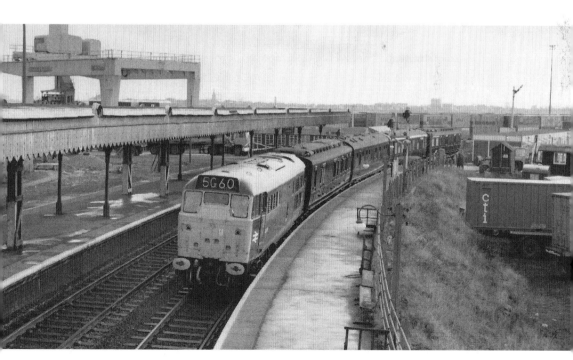

Empty 'Royal Train' coaching stock is seen passing through the platform, en route to the station sidings in December 1969. (ATW Collection)

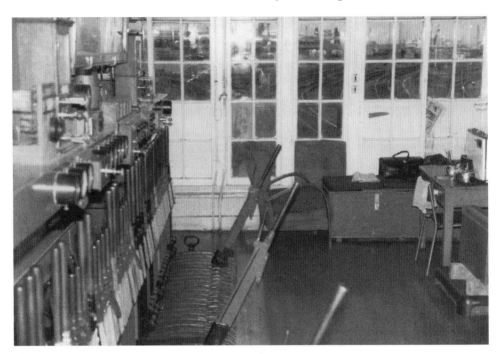

An internal view taken in Parkeston Goods Junction signal box, looking through the windows at the station facilities. (CVRPL Collection)

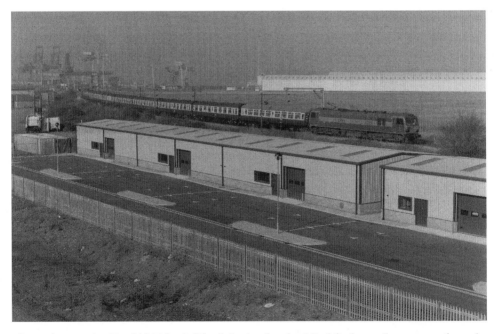

Electric locomotive No. 90031 leads 'The Spinning Sparkey' Pathfinders rail tour away from the station towards Harwich Town on 22 February 2003. Electric locomotive No. 86604 is on the rear of the train as there are no run round facilities at the terminus anymore. (ATW Collection)

Dovercourt

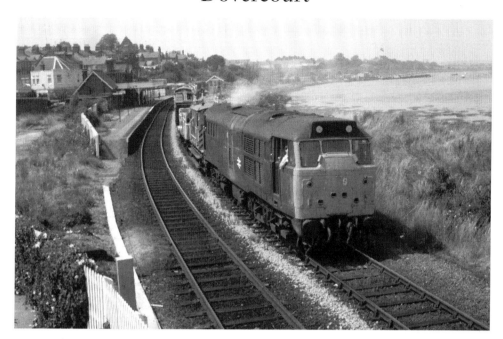

Class 31 diesel No. 31179 is seen on the through siding whilst working an electrification foundations train on 25 July 1983. By this time the Up dock and connections had all been closed and lifted. (ATW Collection)

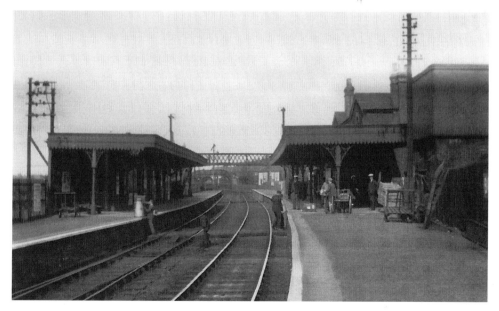

A view of the station from the 1930s with staff moving milk churns from one platform to another. This view is looking east towards Harwich Town. (Stations UK)

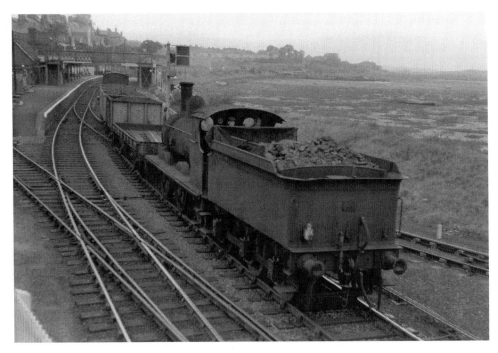

Class J15 locomotive No. 65445 working a local freight over the Down line in the 1950s. The main station buildings are in the background. (Dr I. C. Allen/Transport Treasury)

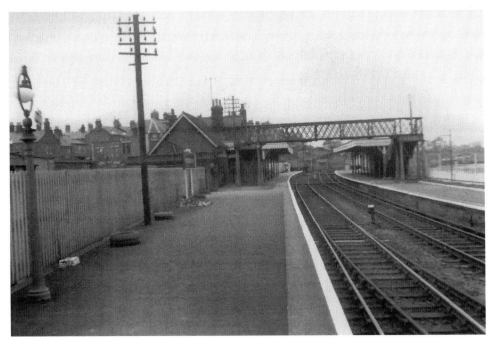

A general view looking west from the Up platform. This was taken in 1959 when the station was still complete with a footbridge. (Stations UK)

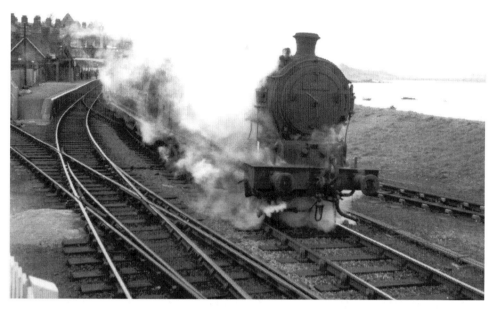

Class N7 locomotive No. 69691 restarts its train during the 1950s, shrouded in steam. Parkeston shed had an allocation of four N7s for local passenger work. (Dr I. C. Allen/Transport Treasury)

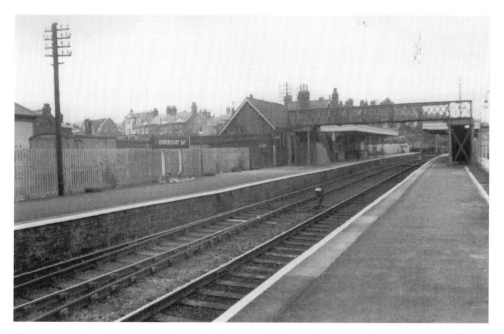

The station viewed from the Down platform in 1959, looking west. Note the vans in the Up dock line; today there are houses built on the former railway sidings. (Stations UK)

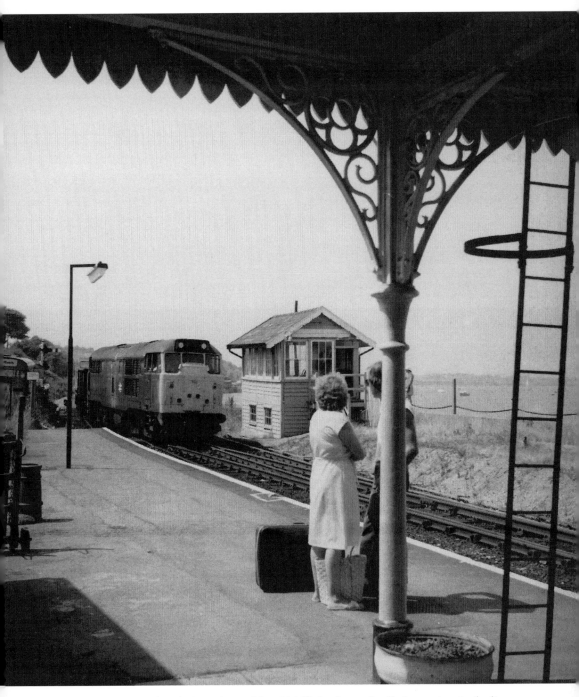

Passengers wait for their train as No. 31179 is shunted off the main single line onto the through siding whilst working an electrification foundations train on 25 July 1983. (ATW Collection)

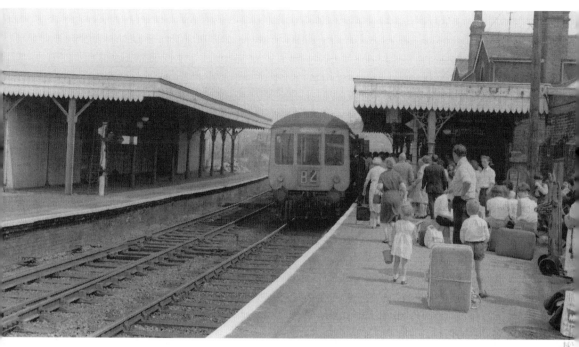

A Class 100 Gloucester type local service DMU arrives from Harwich Town. It seems to be full of passengers during August 1969. (ATW Collection)

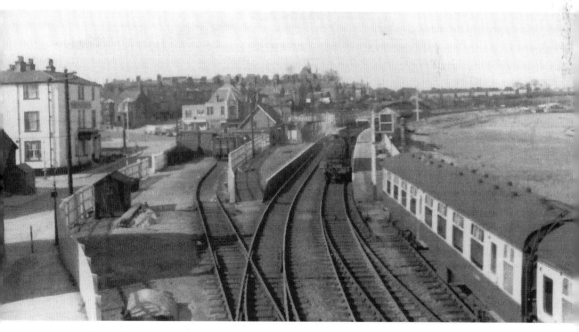

The view from the adjacent public footpath bridge of the station in 1957 as a light locomotive approaches on the Down line. The track layout had changed in 1944 when a facing connection replaced the trailing slip to and from the siding where the coaches are stabled. (Stations UK)

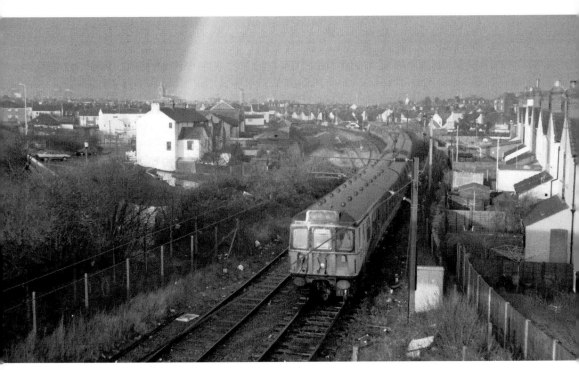

A rainbow appears after a heavy shower of rain as a Class 312 arrives, working a local service to Manningtree, on 13 March 2004. (ATW Collection)

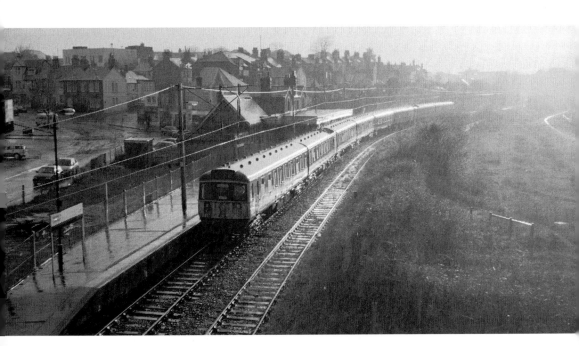

Looking the other way from the previous photograph, a rather wet station sees a pair of Class 312 EMUs departing westwards from the station on 13 March 2004. (ATW Collection)

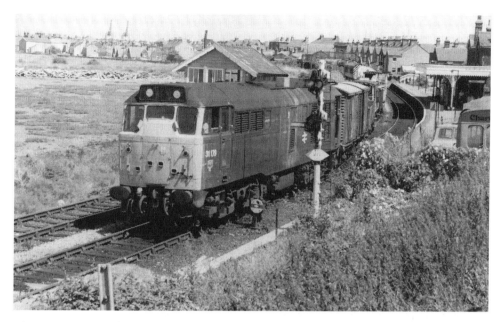

Class 31 No. 31179 exits the through siding with an engineers' electrification train on 22 July 1983. The signal in the foreground is Harwich Town's outer home and shunt ahead signals, worked by levers five and six respectively. (ATW Collection)

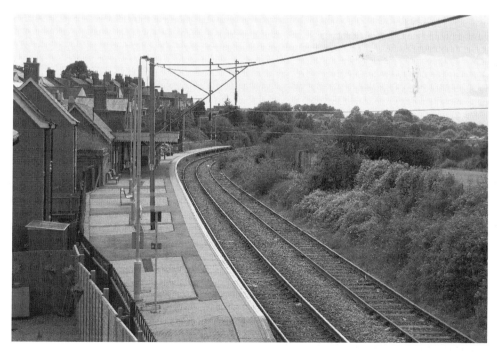

Dovercourt station, seen from the public footpath bridge in August 2018. Houses have been built right up to the platform boundary fence. There is no sign of the former Down platform. The through siding is intact but does not see any traffic these days. (Ray Bishop)

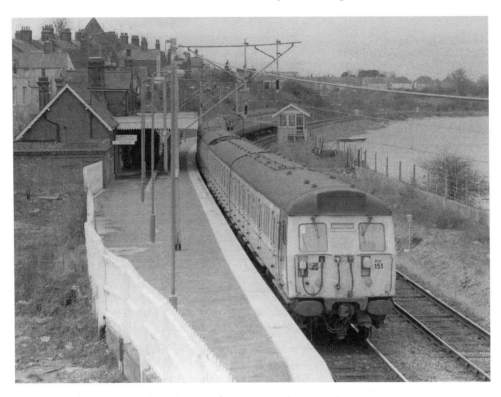

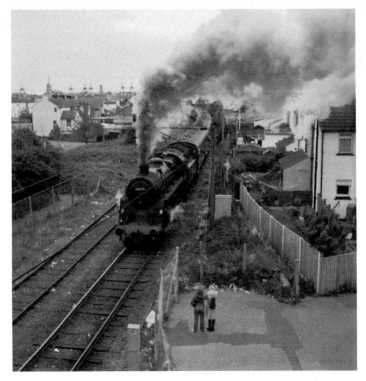

Above: EMUs Nos 308140 and 308151 work an electric test train through the station on 14 April 1986. Only the single passenger line had been electrified; the other line was designated a Through Siding. (ATW Collection)

Left: Steam returns to the branch as locomotive No. 76079 approaches the station, seen from the public footbridge crossing on 5 May 2002. The special was named the 'Lifeboat Express'. (ATW Collection)

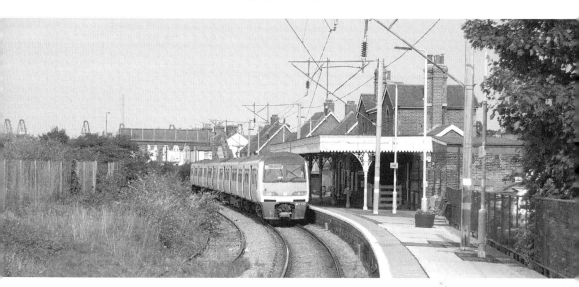

A Class 321 stops at the station in August 2018. The through siding is slowly disappearing under weeds. (Ray Bishop)

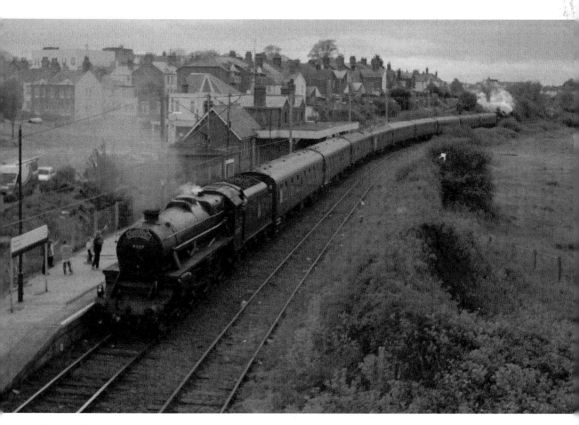

The 'Lifeboat Express' steam special is seen passing through the station with steam locomotives Nos 45407 and 76079 on 5 May 2002. (ATW Collection)

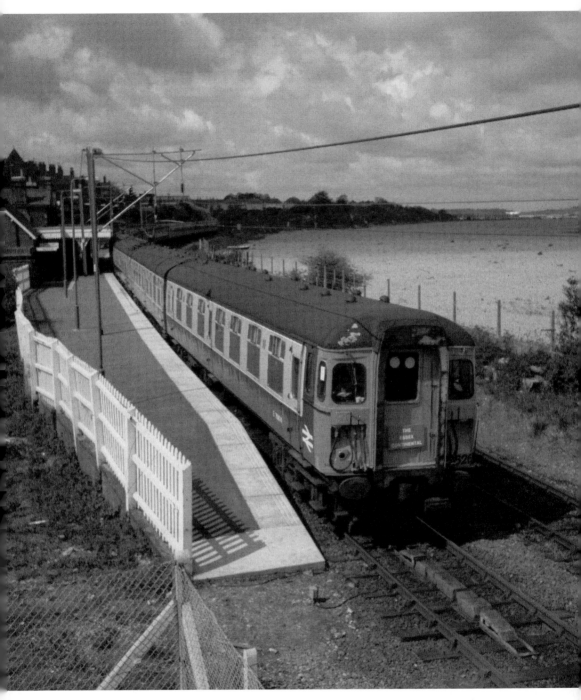

A Class 309 EMU working the 'Essex Continental' departs from the station on 15 May 1986. Prior to electrification, the Class 309 units were normally seen on Clacton and Walton workings. (ATW Collection)

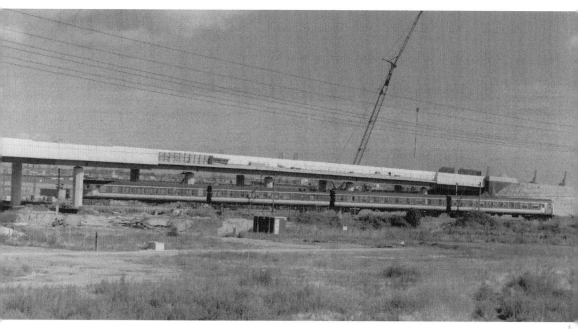

EMU No. 312718 is seen passing under the partially completed Dovercourt bypass road bridge on 17 September 1991. (ATW Collection)

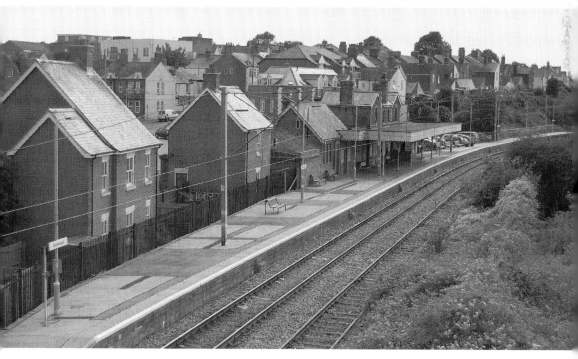

An elevated view of the station and single platform, looking towards Manningtree, as seen in August 2018. The former Down platform is now just a mound of vegetation. (Ray Bishop)

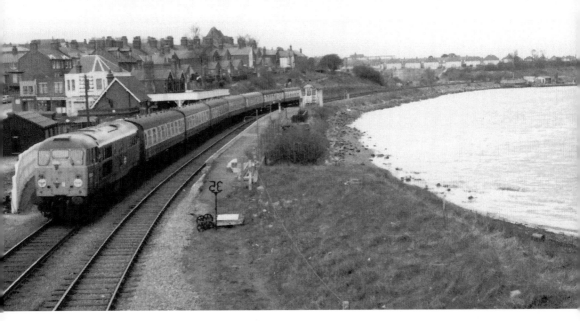

Brush Type 2 diesel, later designated Class 31, No. D5514, working a passenger train through the station post in 1968. There was a reduction in facilities when the passenger line was singled between Parkeston Quay and Harwich Town. (Dr I.C. Allen/Transport Treasury)

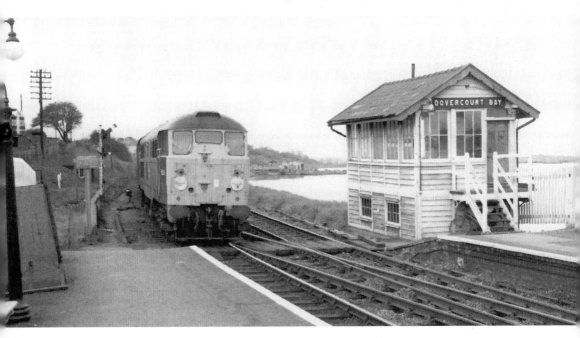

No. D5515 passes Harwich Town's outer home signal as the engine hauls a train into the station. The former Dovercourt Bay signal box had (by then) been reduced to ground frame status and was retained to work the connection in the foreground. (Dr I.C. Allen/Transport Treasury)

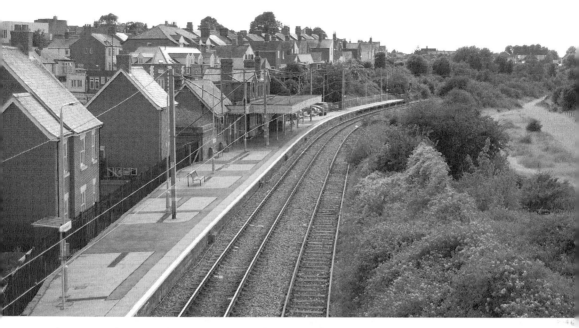

A dry August day in 2018 as the station waits for its next train. The basic hourly service suffices for all needs. Phoro: Ray Bishop)

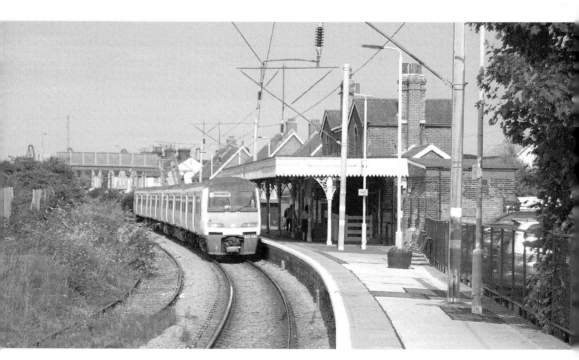

A close-up of a Class 321 EMU arriving at the restored station; surprisingly, the station retains its canopy. The tidy station is let down by the overgrown through siding opposite the platform. (Ray Bishop)

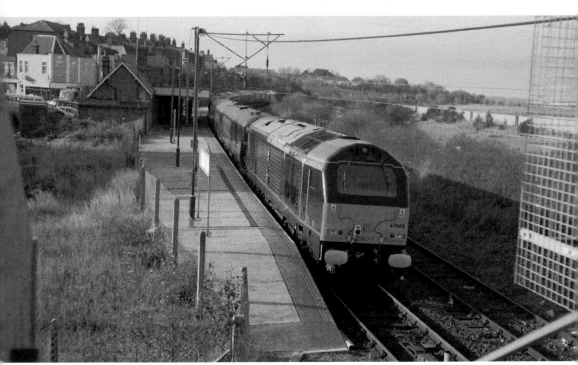

Diesel locomotives Nos 67005 and 67002 top and tail the 'Royal Train', seen passing through the station on 25 November 2004. The train had visited Harwich Town earlier. (ATW Collection)

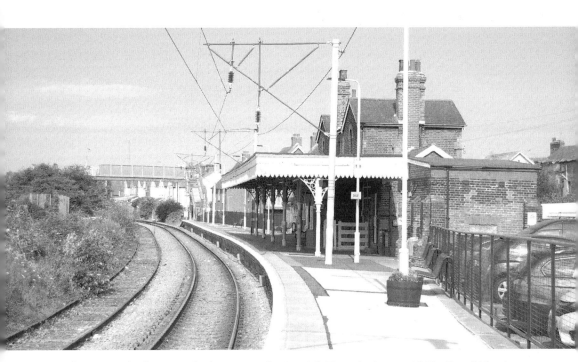

The neat and tidy station looking towards Harwich Town in August 2018. (Ray Bishop)

Harwich Town

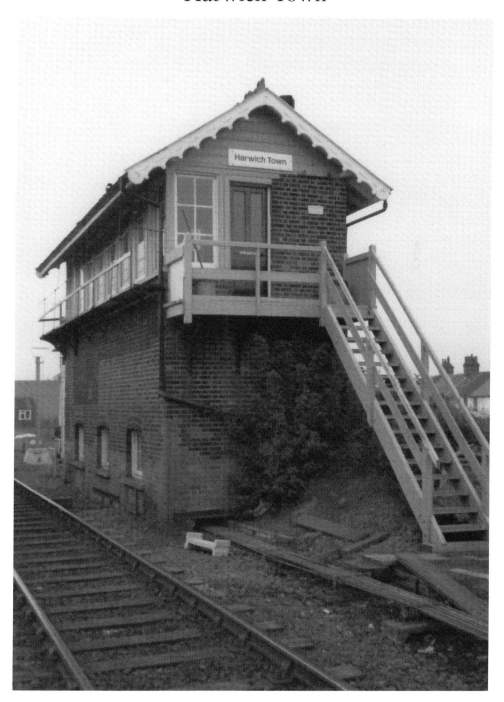

A close-up of the terminus signal box taken from the adjacent Maria Street level crossing, which would later be reduced in status to a public footpath crossing only. This view was taken in the early 1980s. (ATW Collection)

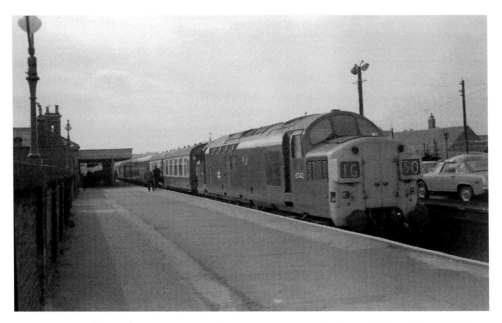

From 1970 until May 1979 Prinz Line ferry passengers travelled to and from Harwich Town. The first train, 1G30, hauled by a Class 37 diesel, is seen standing at the platform on 20 March 1970. (ATW Collection)

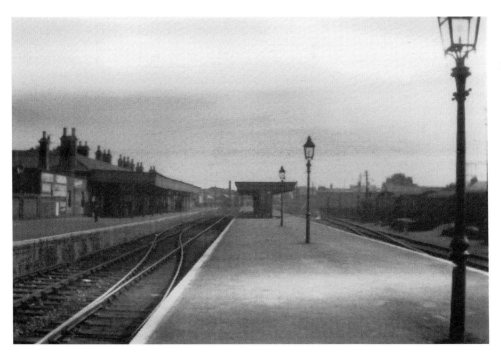

The view looking west from Platforms 1 and 2 at the terminus station. The platform on the left was designated the departure platform. Access to the island platform was via a connecting path behind the buffer stops. This view is from the 1930s. (Stations UK)

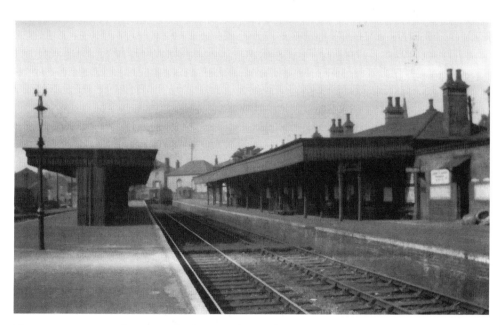

No. D6743 and a boat train service are seen from the buffer stops. A car transporter is in the former Platforms 2 and 3 and is being unloaded for export via the train ferry. The date is 20 March 1970. (ATW Collection)

The station seen in the 1930s, looking at the buffer stops. The main buildings were on the departure platform whilst a canopy and waiting rooms sufficed for the island platform. (Stations UK)

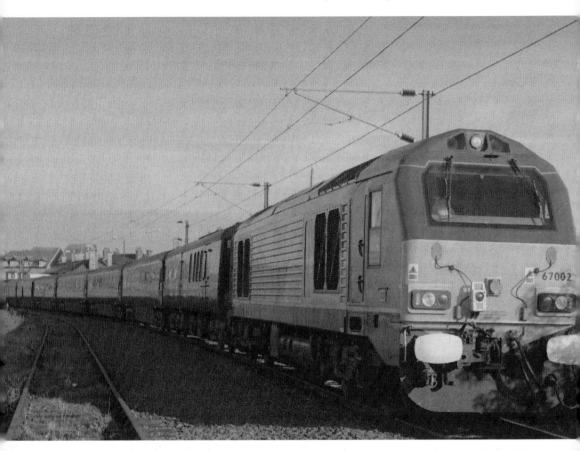

A panoramic view of the 'Royal Train', standing at the terminus on 25 November 2004. The train had locomotive No. 67005 on the far end and No. 67002 on the close end. By this time there was no run round facilities at the terminus station. (ATW Collection)

Opposite above: A 1959 view from the buffer stops looking west with a Cravens type DMU standing in the platform. (Stations UK)

Opposite below: Class 37 diesel No. D6743, now at the leading end of a train. This view was taken from the adjacent car transporter train on 20 March 1970. (ATW Collection)

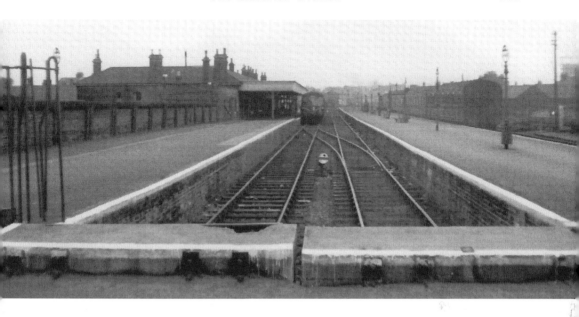

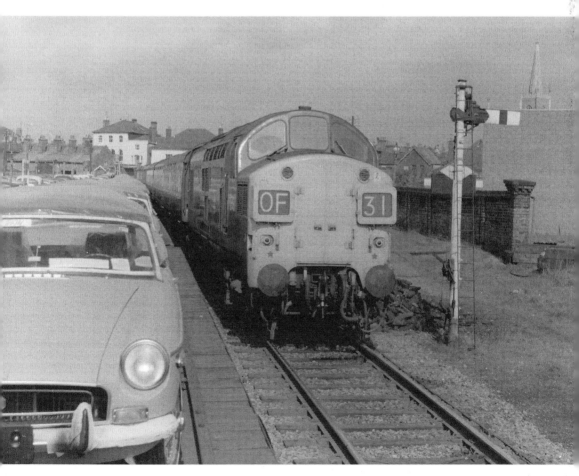

A view of the terminus, seen from Maria Street foot crossing in the mid-1990s. The former goods shed can be seen in the centre background. (Andy Wallis)

In 1994, the foot crossing at Maria Street crossed four tracks. After the closure of the train ferry service, the crossing was reduced to just one track, and the sidings were fenced off out of use. (Andy Wallis)

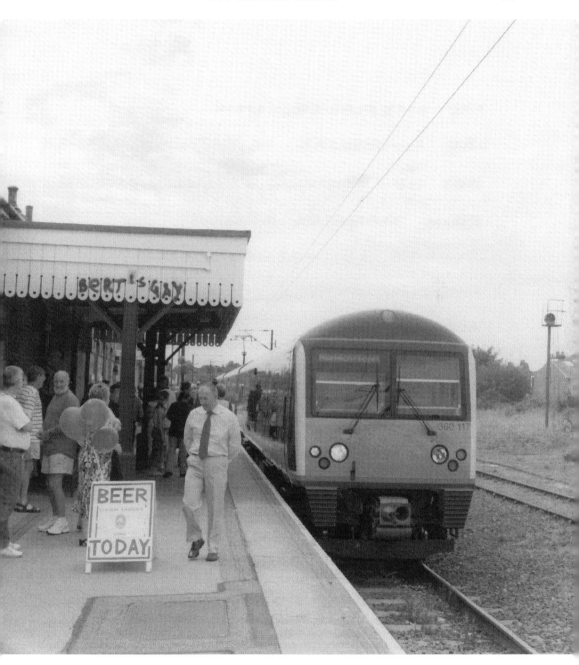

EMU No. 360117 stands in the platform during the branch line's 150th anniversary celebrations on 15 August 2004. (ATW Collection)

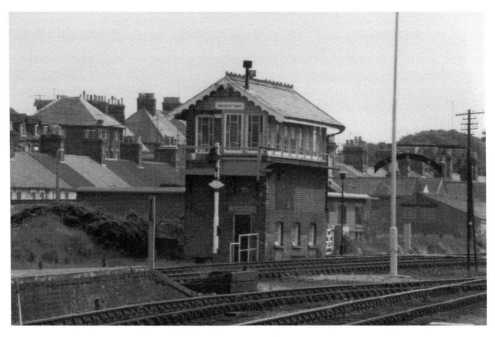

An exterior view of the signal box seen from the yard. The semaphore home signal was worked by lever twenty-three and survived until closure of the signal box on 1 December 1985. (CVRPL Collection)

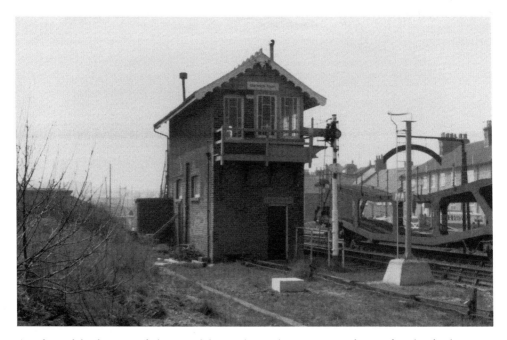

A side and back view of the signal box. The replacement signal post for the forthcoming resignalling can be seen in the foreground. Note the heavy-duty loading gauge straddling the siding. (CVRPL Collection)

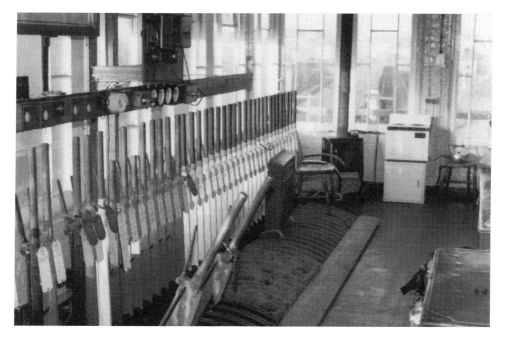

An interior view of the signal box, equipped with a fifty-lever McKenzie & Holland lever frame. The white levers are spare and came about in the late 1960s reduction in facilities. (CVRPL Collection)

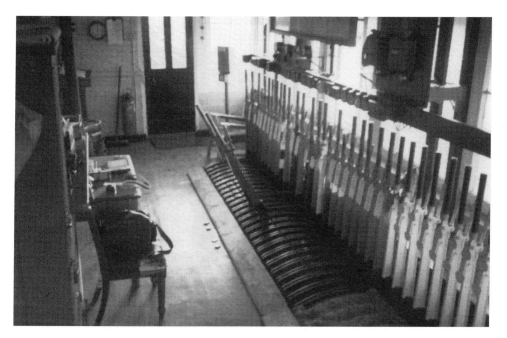

The other view inside the signal box, looking west. At its busiest, the lever frame had forty-eight working levers. By the time of this picture, this had been reduced to just twenty-two. The signal box finally closed on 1 December 1985. (CVRPL Collection)

Class 308 EMUs Nos 308140 and 308150 get ready to depart from the station with the first electric test train on 14 April 1986. The full electric service commenced with the summer timetable in May 1986. (ATW Collection)

A view taken from the signal box balcony, looking at the station in happier times with DMUs in the platform and a car transporter train in the yard. (ATW Collection)

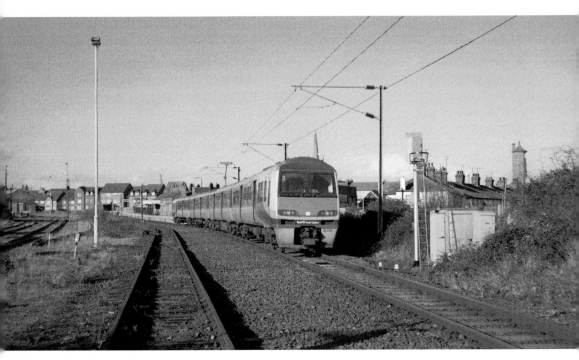

A Class 321 EMU departs from the station past the colour light signal P58 protecting the level crossings. By this time the train ferry service had finished, so the through siding and yard were becoming overgrown with weeds. This view was taken from Maria Street footpath crossing and is dated 13 March 2004. (ATW Collection)

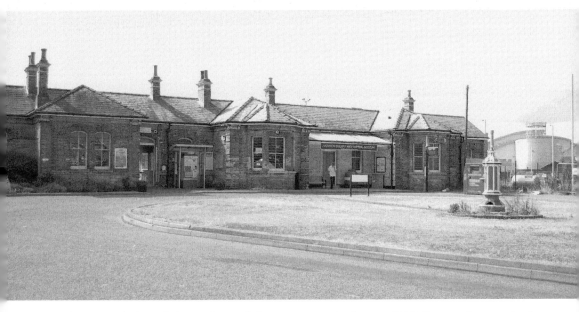

An external view of the station and forecourt, seen in August 2018. Restoration was in the process of taking place. (Ray Bishop)

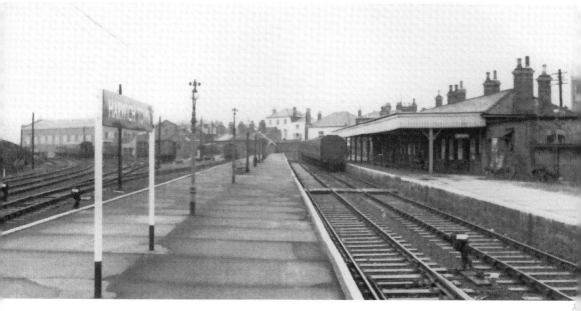

A close-up view of the station taken from the Down arrival platform. Numbered as Platform 1, trains could depart from Platform 2 or from the main Up platform, which is where the station buildings are. (Stations UK)

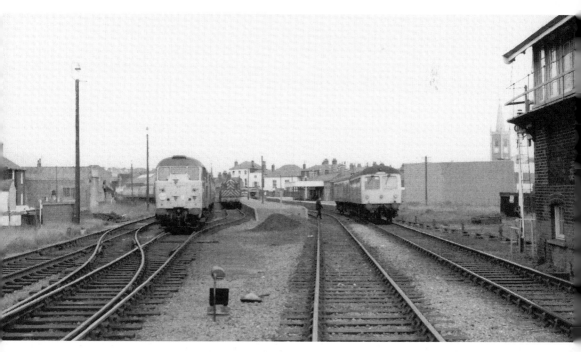

An undated track-level picture looking back towards the platforms, with a DMU departing and a Class 31 on a train of coaching stock in the siding. A Class 08 shunting engine stands on the other line. (Dr I. C. Allen/Transport Treasury)

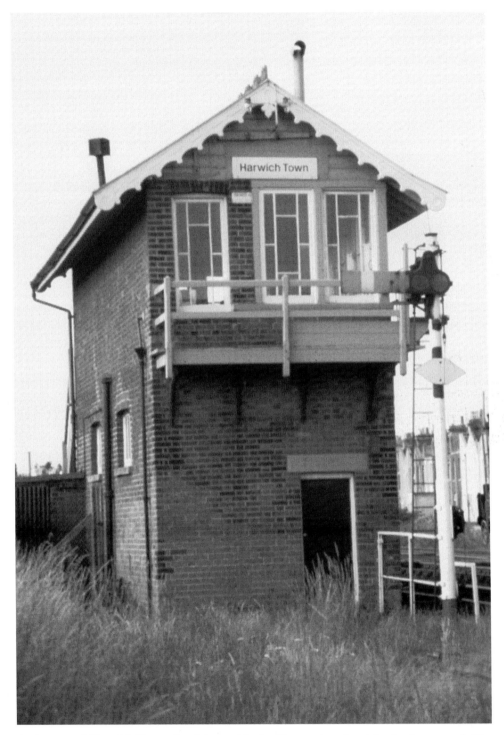

A close-up of Harwich Town signal box with the Up starting signal in the foreground. The signal box controlled the adjacent Maria Street level crossing, as well as supervising the next crossing at Alexandra Road. (John Tinkler Collection)

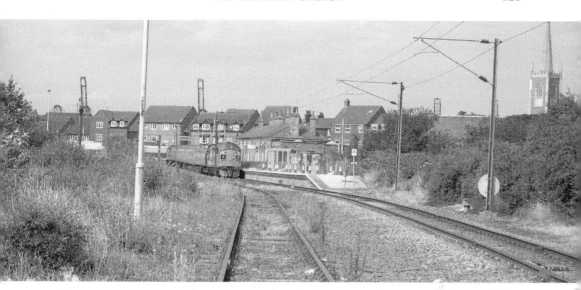

A Network Rail test train, top and tailed with Class 37 diesels, pays a visit to the terminus station in August 2018. Diesels were a rare sight east of Harwich International by this time. (Ray Bishop)

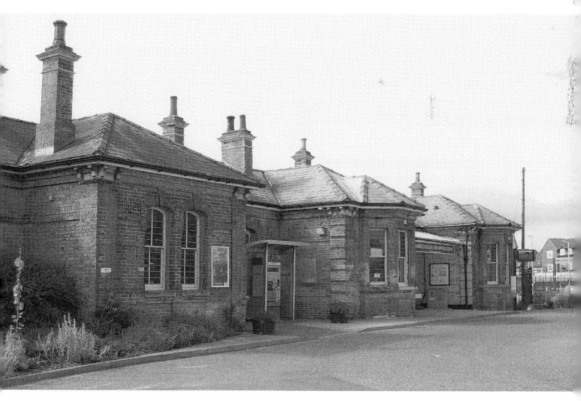

A close-up view of the restored terminus buildings, which are let out for commercial use these days. Seen in August 2018. (Ray Bishop)

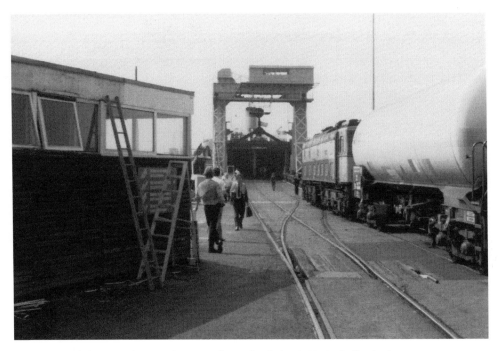

A close-up of the train ferry with a train being loaded. (CVRPL Collection)

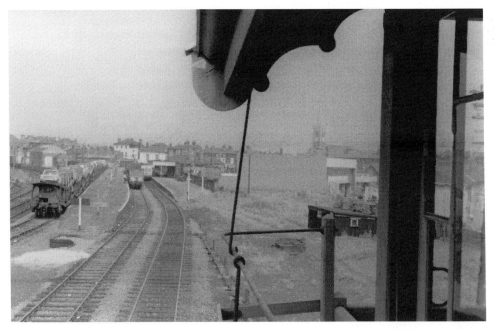

A view looking back at the station from the balcony of the signal box. DMUs can be seen in two of the platforms with a car transporter train in the other platform. This view is dated 2 August 1969. By this time the line had been singled between Harwich Town and Parkeston Quay, leaving just one usable platform for passenger trains. (ATW Collection)

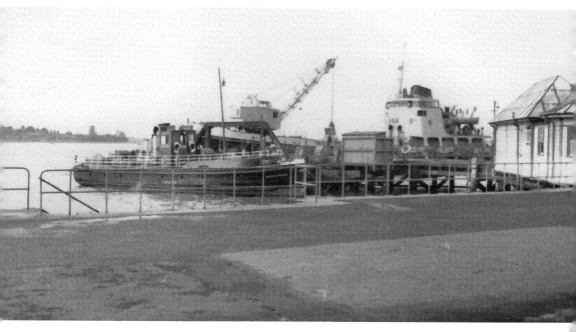

Harwich Train Ferry terminal seen in 1961. At its busiest there was a ferry departure every six hours to the continent. Later on, traffic fell and the train service between Harwich and Zeebrugge ceased on 30 January 1987. (Stations UK)

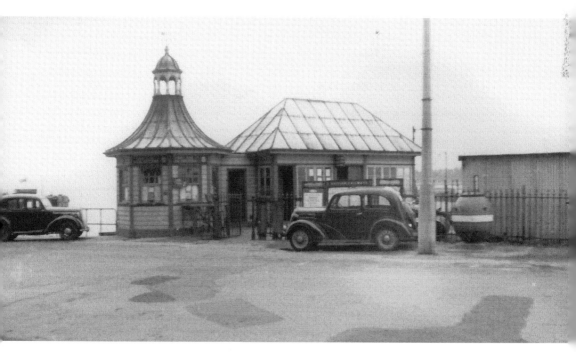

The exterior of Harwich Pier. It is seen in 1959, complete with period cars of that time in the foreground. (Stations UK)

Acknowledgements and Further Reading

Special thanks to Ray Bishop, Dickie Pearce, Lens of Suttons Association and Peter Mortimer for help with the archive views. Thanks also to all the other photographers and organisations that have provided views from their collections.

For those interested, further information about the line included in this volume can be found in the following publications:

Gordon, D. I., *Regional History of Railways Volume 5 The Eastern Counties* (David & Charles, 1968/1977).
Mitchell, Vic, *Branch Lines to Harwich and Hadleigh* (Middleton Press, 2011).